S0-BNG-210

SPA & HEALTH CLUB DESIGN

teNeues

Editors:	Encarna Castillo, Ana G. Cañizares
Copy editing:	Cristina Doncel
Layout:	Carlo Sansone
Translations:	Maurizio Siliato (Italian), Susanne Engler (German) Marion Westerhoff (French), Richard Lewis (English)

Produced by Loft Publications
www.loftpublications.com

Published by teNeues Publishing Group

teNeues Publishing Company
16 West 22nd Street, New York, NY 10010, USA
Tel.: 001-212-627-9090, Fax: 001-212-627-9511

teNeues Book Division
Kaistraße 18
40221 Düsseldorf, Germany
Tel.: 0049-(0)211-994597-0, Fax: 0049-(0)211-994597-40

teNeues Publishing UK Ltd.
P.O. Box 402
West Byfleet
KT14 7ZF, Great Britain
Tel.: 0044-1932-403509, Fax: 0044-1932-403514

teNeues France S.A.R.L.
4, rue de Valence
75005 Paris, France
Tel.: 0033-1-55 76 62 05, Fax: 0033-1-55 76 64 19

teNeues Iberica S.L.
Pso. Juan de la Encina 2–48, Urb. Club de Campo
28700 S.S.R.R., Madrid, Spain
Tel./Fax: 0034-91-65 95 876

www.teneues.com

| ISBN-10: | 3-8327-9074-8 |
| ISBN-13: | 978-3-8327-9074-5 |

© 2005 teNeues Verlag GmbH + Co. KG, Kempen

Printed in Spain

Picture and text rights reserved for all countries.
No part of this publication may be reproduced in any
manner whatsoever.

All rights reserved.

While we strive for utmost precision in every detail,
we cannot be held responsible for any inaccuracies,
neither for any subsequent loss or damage arising.

Bibliographic information published by
Die Deutsche Bibliothek. Die Deutsche Bibliothek lists
this publication in the Deutsche Nationalbibliografie;
detailed bibliographic data is available in the Internet
at http://dnb.ddb.de.

INTRODUCTION

EINLEITUNG

INTRODUCTION

INTRODUCCIÓN

INTRODUZIONE

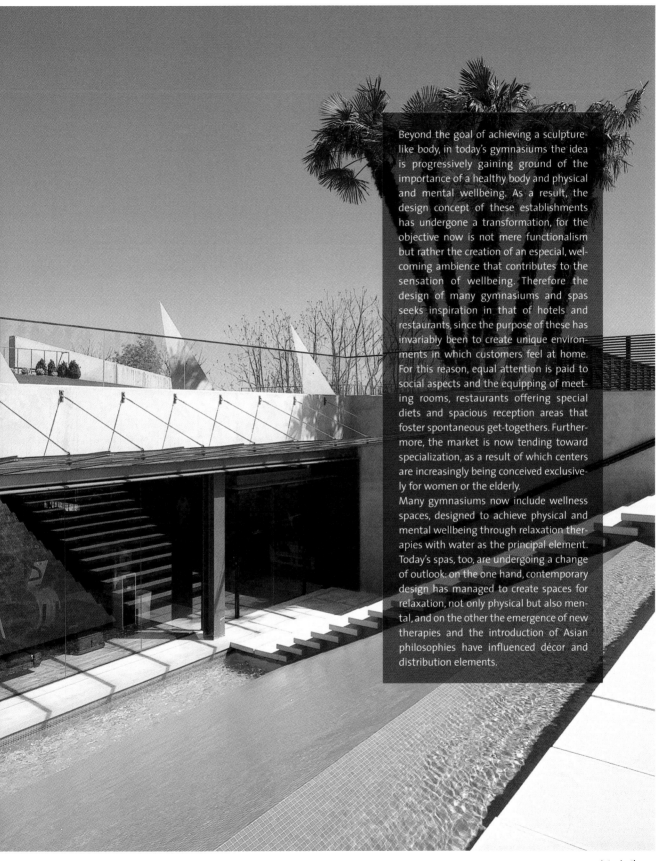

Beyond the goal of achieving a sculpture-like body, in today's gymnasiums the idea is progressively gaining ground of the importance of a healthy body and physical and mental wellbeing. As a result, the design concept of these establishments has undergone a transformation, for the objective now is not mere functionalism but rather the creation of an especial, welcoming ambience that contributes to the sensation of wellbeing. Therefore the design of many gymnasiums and spas seeks inspiration in that of hotels and restaurants, since the purpose of these has invariably been to create unique environments in which customers feel at home. For this reason, equal attention is paid to social aspects and the equipping of meeting rooms, restaurants offering special diets and spacious reception areas that foster spontaneous get-togethers. Furthermore, the market is now tending toward specialization, as a result of which centers are increasingly being conceived exclusively for women or the elderly.

Many gymnasiums now include wellness spaces, designed to achieve physical and mental wellbeing through relaxation therapies with water as the principal element. Today's spas, too, are undergoing a change of outlook: on the one hand, contemporary design has managed to create spaces for relaxation, not only physical but also mental, and on the other the emergence of new therapies and the introduction of Asian philosophies have influenced décor and distribution elements.

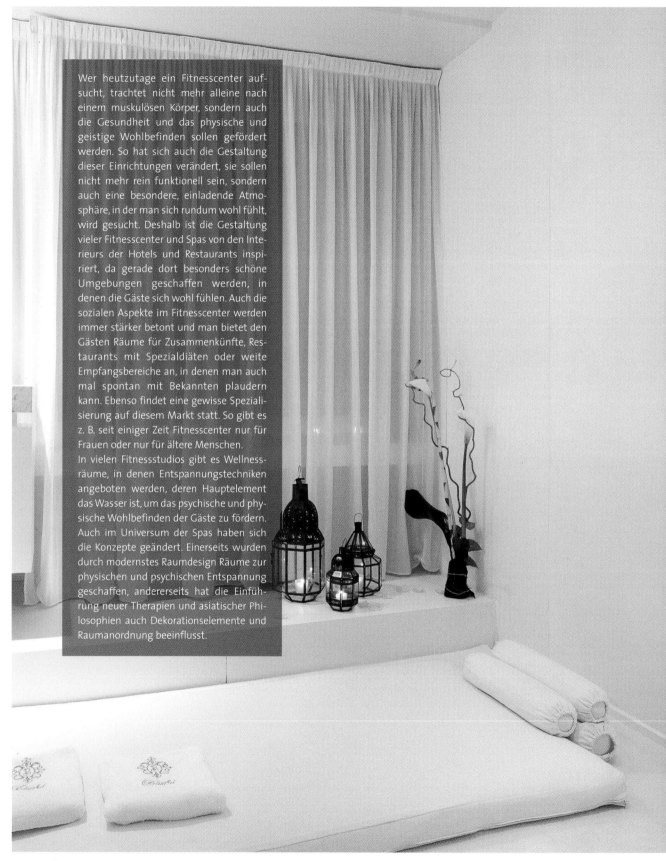

Wer heutzutage ein Fitnesscenter aufsucht, trachtet nicht mehr alleine nach einem muskulösen Körper, sondern auch die Gesundheit und das physische und geistige Wohlbefinden sollen gefördert werden. So hat sich auch die Gestaltung dieser Einrichtungen verändert, sie sollen nicht mehr rein funktionell sein, sondern auch eine besondere, einladende Atmosphäre, in der man sich rundum wohl fühlt, wird gesucht. Deshalb ist die Gestaltung vieler Fitnesscenter und Spas von den Interieurs der Hotels und Restaurants inspiriert, da gerade dort besonders schöne Umgebungen geschaffen werden, in denen die Gäste sich wohl fühlen. Auch die sozialen Aspekte im Fitnesscenter werden immer stärker betont und man bietet den Gästen Räume für Zusammenkünfte, Restaurants mit Spezialdiäten oder weite Empfangsbereiche an, in denen man auch mal spontan mit Bekannten plaudern kann. Ebenso findet eine gewisse Spezialisierung auf diesem Markt statt. So gibt es z. B. seit einiger Zeit Fitnesscenter nur für Frauen oder nur für ältere Menschen.

In vielen Fitnessstudios gibt es Wellnessräume, in denen Entspannungstechniken angeboten werden, deren Hauptelement das Wasser ist, um das psychische und physische Wohlbefinden der Gäste zu fördern. Auch im Universum der Spas haben sich die Konzepte geändert. Einerseits wurden durch modernstes Raumdesign Räume zur physischen und psychischen Entspannung geschaffen, andererseits hat die Einführung neuer Therapien und asiatischer Philosophien auch Dekorationselemente und Raumanordnung beeinflusst.

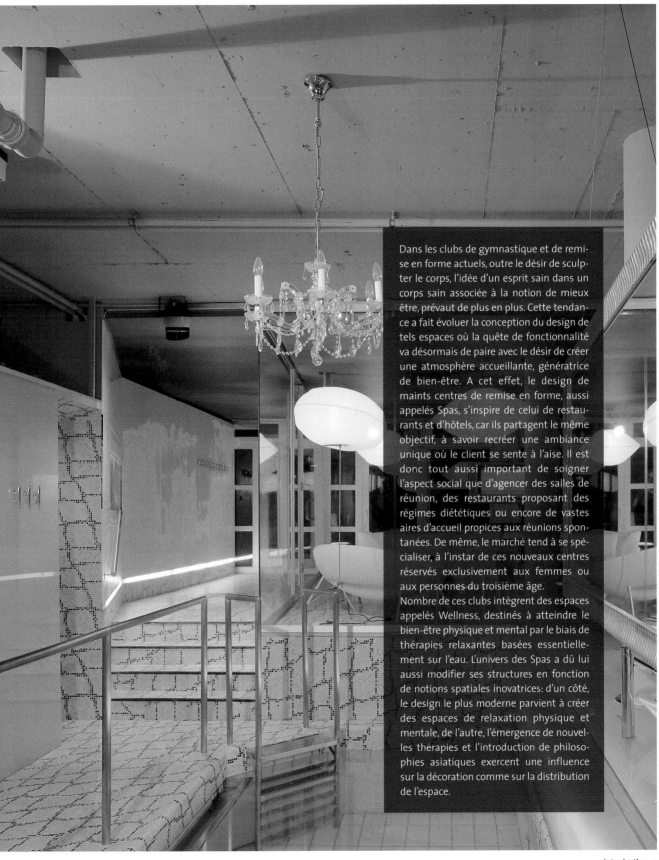

Dans les clubs de gymnastique et de remise en forme actuels, outre le désir de sculpter le corps, l'idée d'un esprit sain dans un corps sain associée à la notion de mieux être, prévaut de plus en plus. Cette tendance a fait évoluer la conception du design de tels espaces où la quête de fonctionnalité va désormais de paire avec le désir de créer une atmosphère accueillante, génératrice de bien-être. A cet effet, le design de maints centres de remise en forme, aussi appelés Spas, s'inspire de celui de restaurants et d'hôtels, car ils partagent le même objectif, à savoir recréer une ambiance unique où le client se sente à l'aise. Il est donc tout aussi important de soigner l'aspect social que d'agencer des salles de réunion, des restaurants proposant des régimes diététiques ou encore de vastes aires d'accueil propices aux réunions spontanées. De même, le marché tend à se spécialiser, à l'instar de ces nouveaux centres réservés exclusivement aux femmes ou aux personnes du troisième âge.

Nombre de ces clubs intègrent des espaces appelés Wellness, destinés à atteindre le bien-être physique et mental par le biais de thérapies relaxantes basées essentiellement sur l'eau. L'univers des Spas a dû lui aussi modifier ses structures en fonction de notions spatiales inovatrices: d'un côté, le design le plus moderne parvient à créer des espaces de relaxation physique et mentale, de l'autre, l'émergence de nouvelles thérapies et l'introduction de philosophies asiatiques exercent une influence sur la décoration comme sur la distribution de l'espace.

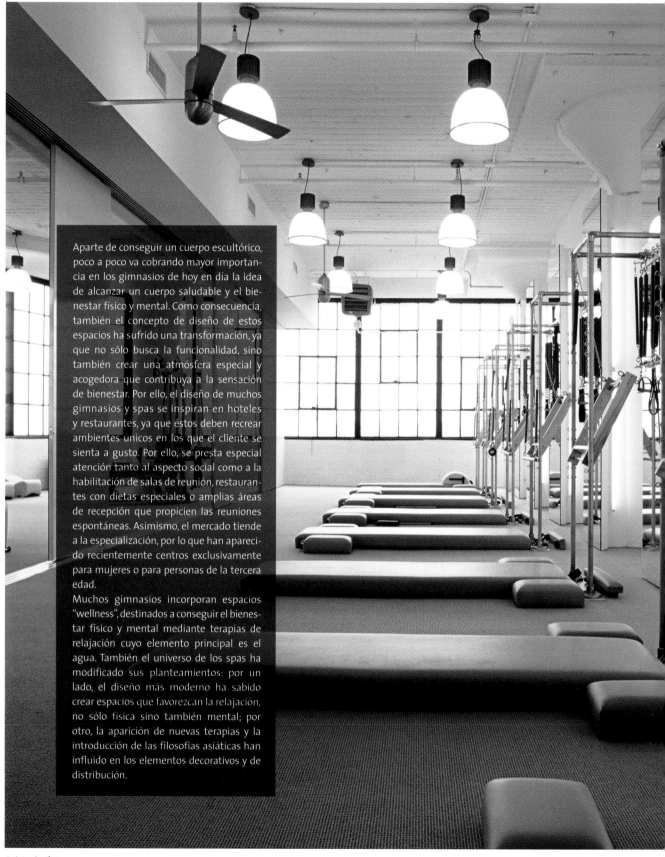

Aparte de conseguir un cuerpo escultórico, poco a poco va cobrando mayor importancia en los gimnasios de hoy en día la idea de alcanzar un cuerpo saludable y el bienestar físico y mental. Como consecuencia, también el concepto de diseño de estos espacios ha sufrido una transformación, ya que no sólo busca la funcionalidad, sino también crear una atmósfera especial y acogedora que contribuya a la sensación de bienestar. Por ello, el diseño de muchos gimnasios y spas se inspiran en hoteles y restaurantes, ya que éstos deben recrear ambientes únicos en los que el cliente se sienta a gusto. Por ello, se presta especial atención tanto al aspecto social como a la habilitación de salas de reunión, restaurantes con dietas especiales o amplias áreas de recepción que propicien las reuniones espontáneas. Asimismo, el mercado tiende a la especialización, por lo que han aparecido recientemente centros exclusivamente para mujeres o para personas de la tercera edad.

Muchos gimnasios incorporan espacios "wellness", destinados a conseguir el bienestar físico y mental mediante terapias de relajación cuyo elemento principal es el agua. También el universo de los spas ha modificado sus planteamientos: por un lado, el diseño más moderno ha sabido crear espacios que favorezcan la relajación, no sólo física sino también mental; por otro, la aparición de nuevas terapias y la introducción de las filosofías asiáticas han influido en los elementos decorativos y de distribución.

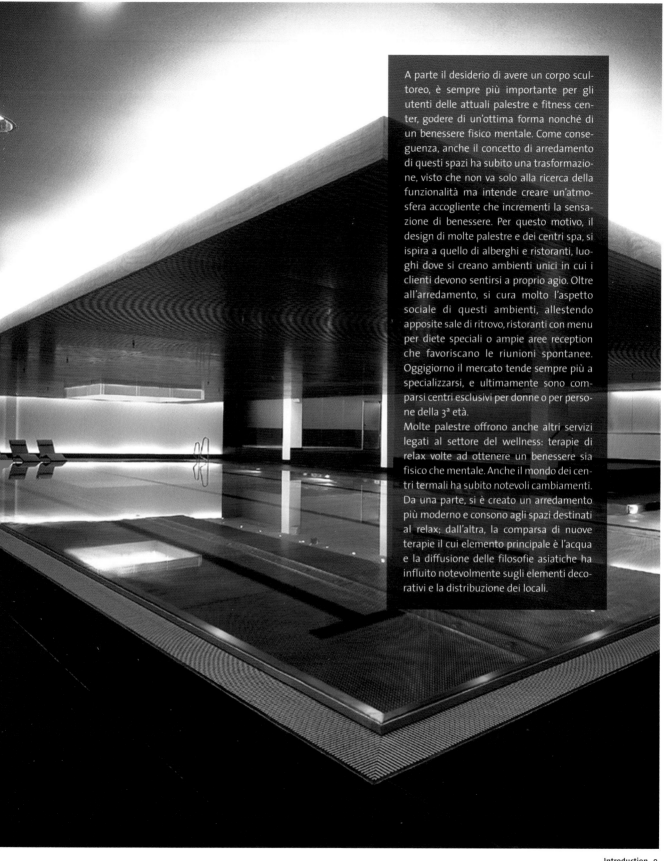

A parte il desiderio di avere un corpo scultoreo, è sempre più importante per gli utenti delle attuali palestre e fitness center, godere di un'ottima forma nonché di un benessere fisico mentale. Come conseguenza, anche il concetto di arredamento di questi spazi ha subito una trasformazione, visto che non va solo alla ricerca della funzionalità ma intende creare un'atmosfera accogliente che incrementi la sensazione di benessere. Per questo motivo, il design di molte palestre e dei centri spa, si ispira a quello di alberghi e ristoranti, luoghi dove si creano ambienti unici in cui i clienti devono sentirsi a proprio agio. Oltre all'arredamento, si cura molto l'aspetto sociale di questi ambienti, allestendo apposite sale di ritrovo, ristoranti con menu per diete speciali o ampie aree reception che favoriscano le riunioni spontanee. Oggigiorno il mercato tende sempre più a specializzarsi, e ultimamente sono comparsi centri esclusivi per donne o per persone della 3ª età.

Molte palestre offrono anche altri servizi legati al settore del wellness: terapie di relax volte ad ottenere un benessere sia fisico che mentale. Anche il mondo dei centri termali ha subito notevoli cambiamenti. Da una parte, si è creato un arredamento più moderno e consono agli spazi destinati al relax; dall'altra, la comparsa di nuove terapie il cui elemento principale è l'acqua e la diffusione delle filosofie asiatiche ha influito notevolmente sugli elementi decorativi e la distribuzione dei locali.

Therme Oberlaa Vienna, Austria

Architect: Love Architecture & Urbanism
Photography: Rupert Steiner
Kurbadstraße 16, 1100, Vienna
Phone: + 43 01 680 09 9700
www.oberlaa.at
Services: Spa, sauna, aqua wellness program, fitness, aerobics, tennis

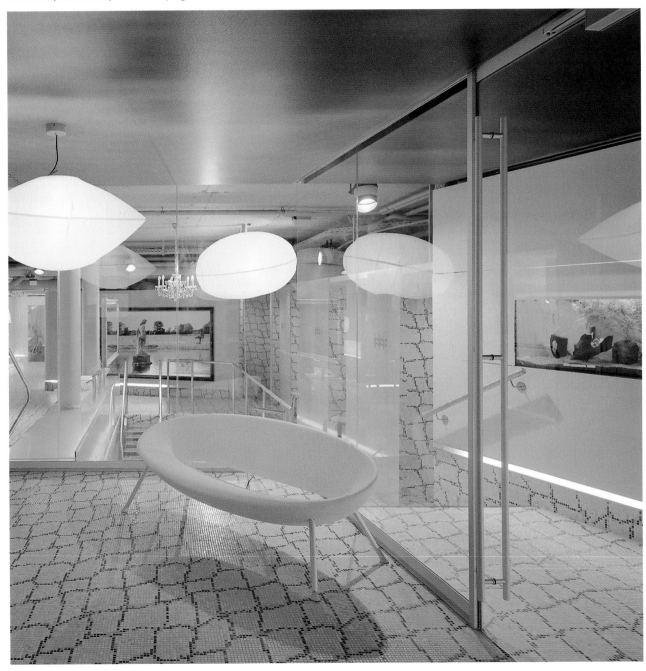

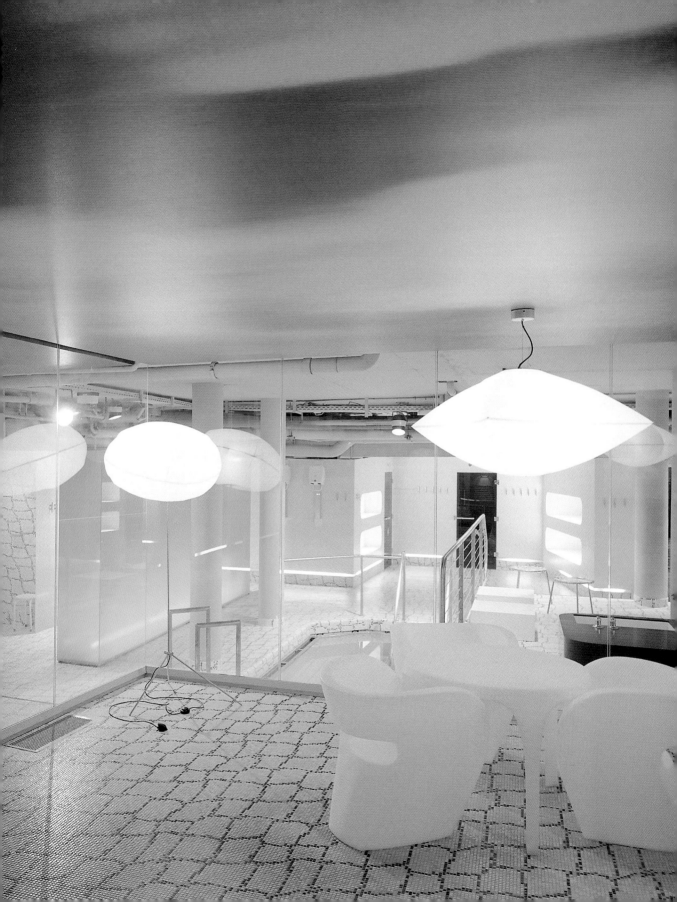

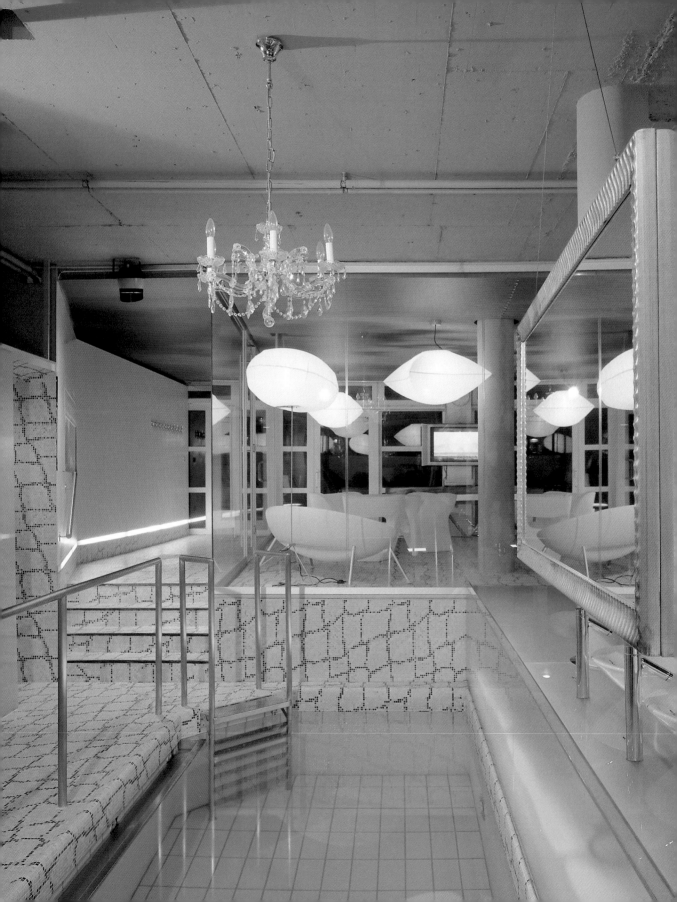

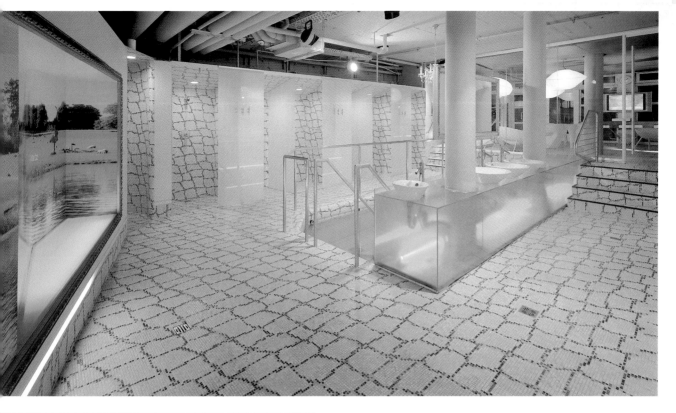

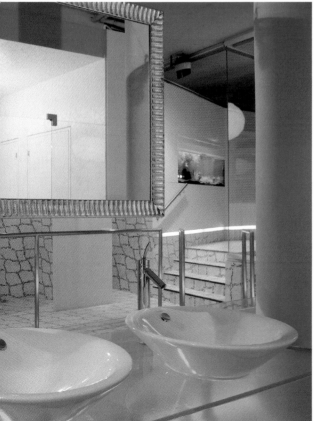

Housed in a building from the 1960s, the interior has been redesigned to adapt to today's requirements and to attract a young clientele.

Diese Therme befindet sich in einem Gebäude aus den Sechzigerjahren. Die Räume wurden modernisiert und zeitgemäß ausgestattet, um ein jüngeres Publikum anzuziehen.

Situé dans un édifice des années 60, l'espace intérieur a été remodelé en fonction des nécessités actuelles et dans le but de séduire une clientèle plus jeune.

Ubicado en un edificio de la década de 1960, el espacio interior ha sido rediseñado para adaptarlo a las necesidades actuales y atraer a una clientela más joven.

Gli interni di questo centro, situato in un edificio costruito negli anni 60, sono stati ridisegnati per adattarli alle esigenze attuali e attirare una clientela più giovane.

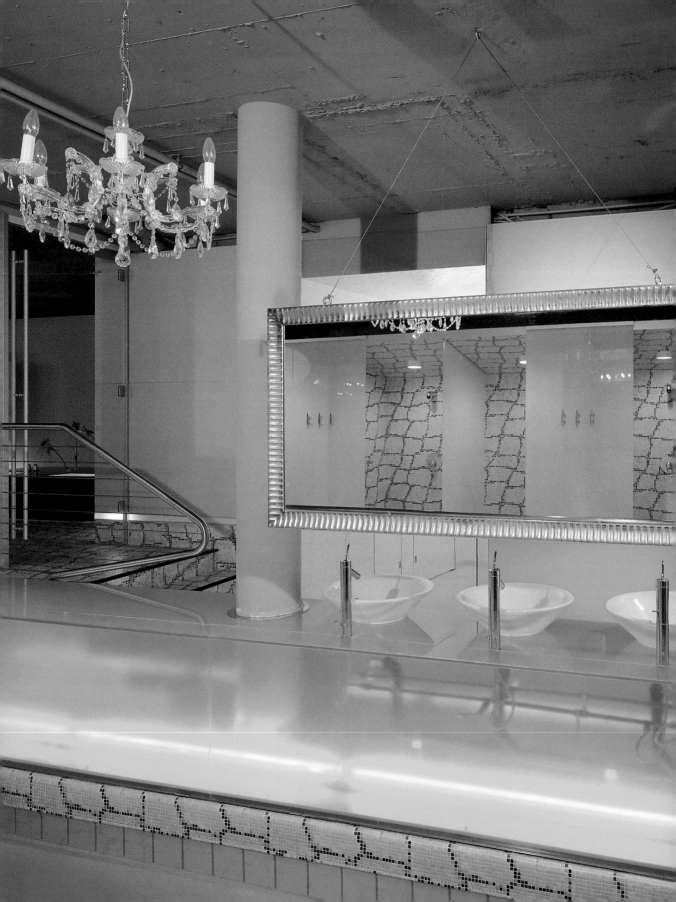

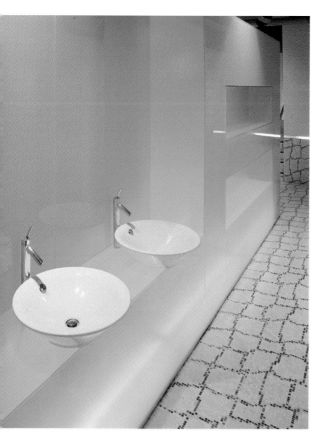
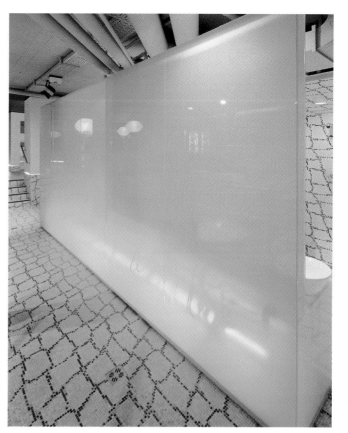
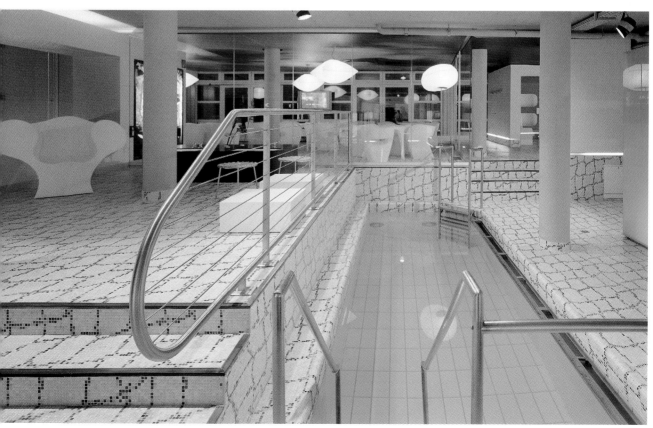

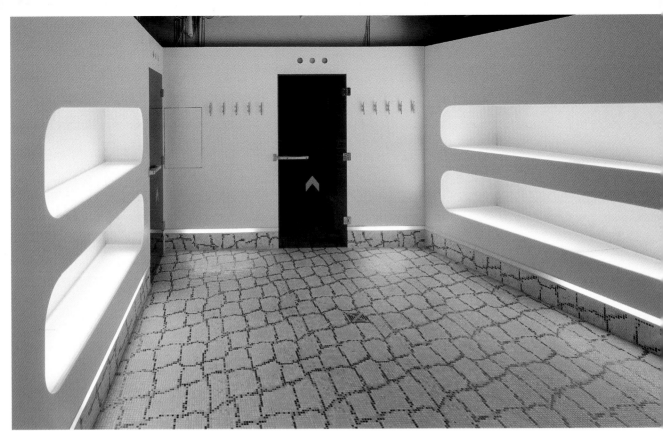

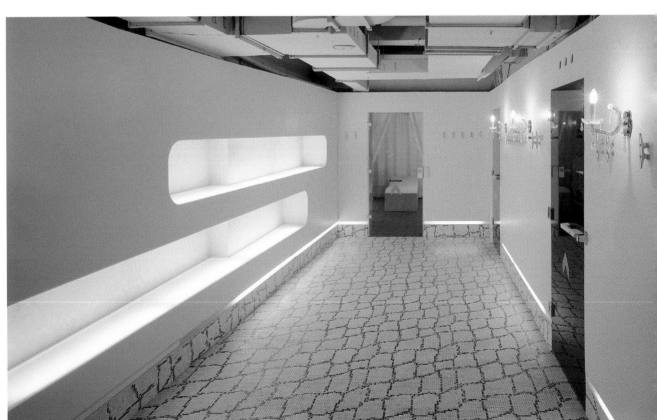

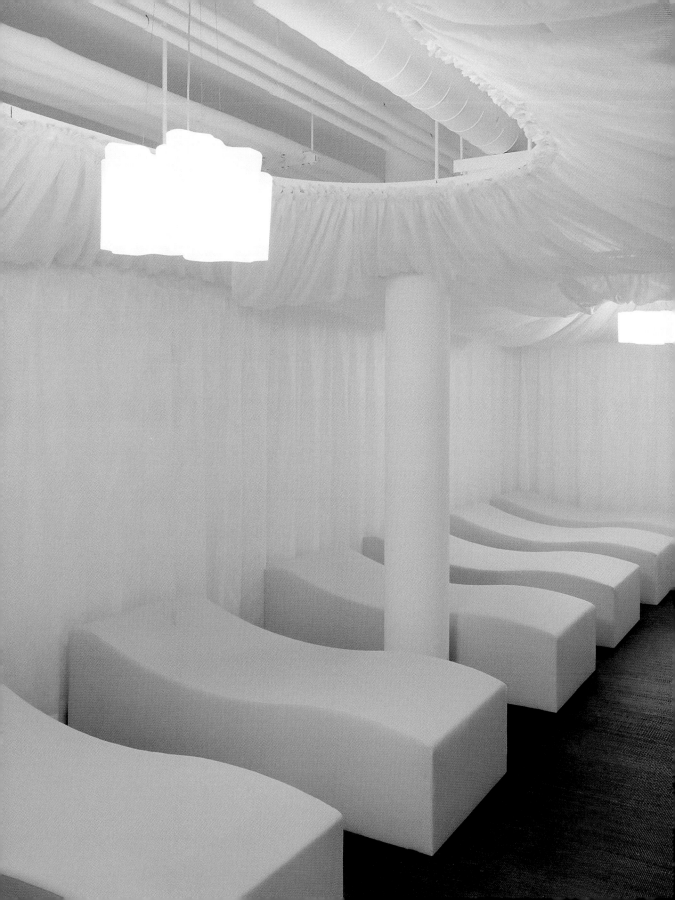

Evian Spa Shanghai, China

Architect: CL3 Architects
Photography: Nacása & Partners
No. 3 The Bund, 2nd Floor, 3 Zhong Shan Dong Yi Road, 200002 Shanghai
Phone: +86 21 6321 6622
www.threeonthebund.com, ateng@on-the-bund.com
Services: 14 treatment rooms, body and beauty treatments, body massage, bathcare, Asian and Western techniques

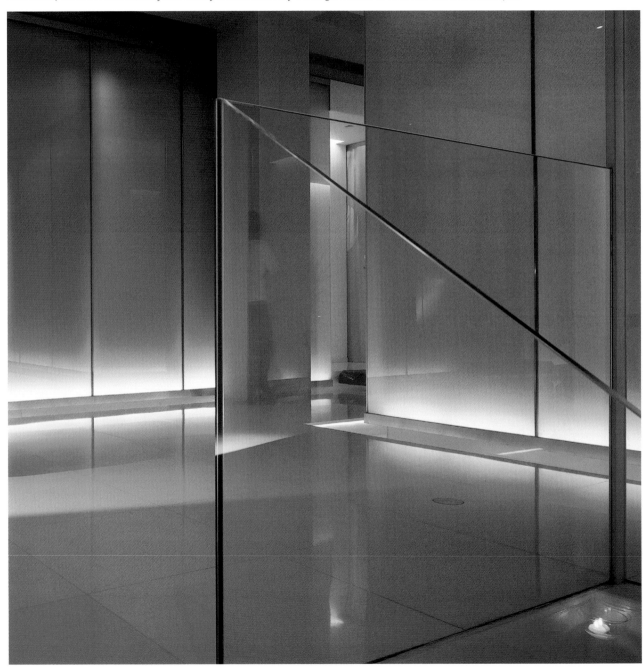

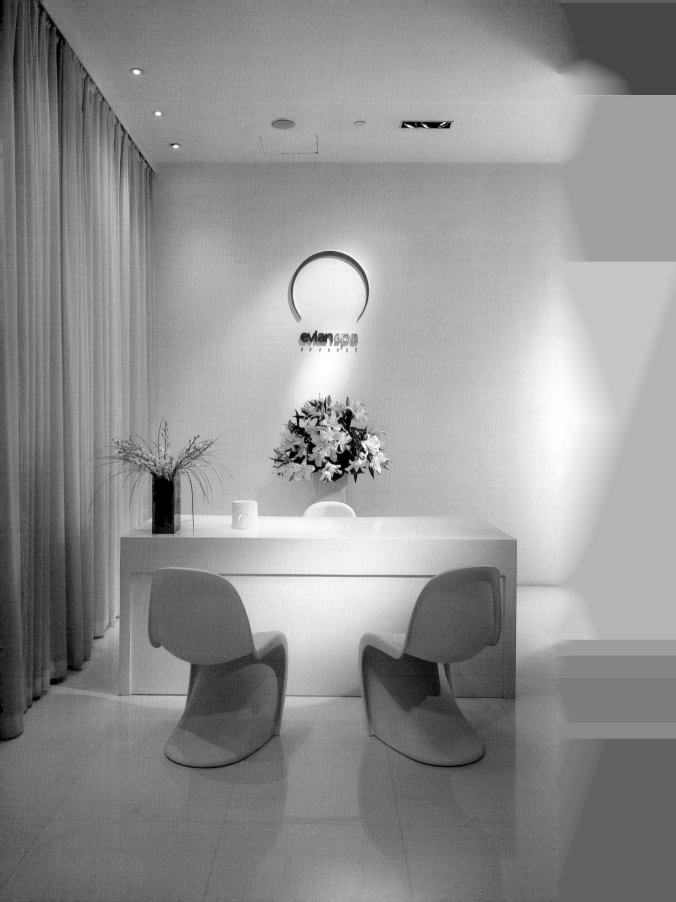

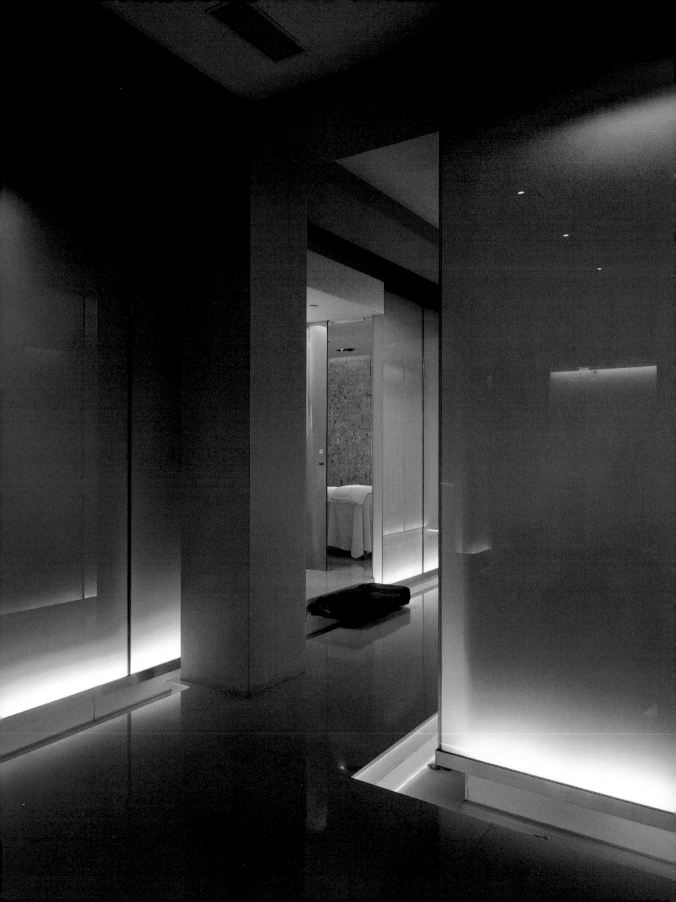

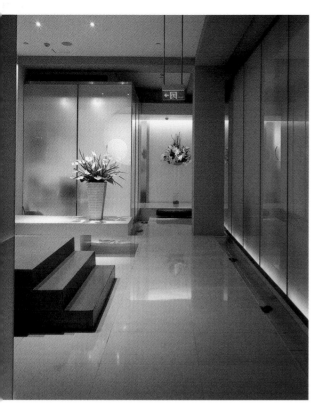

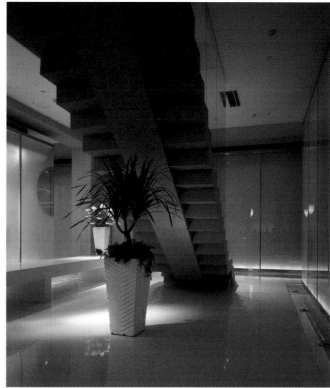

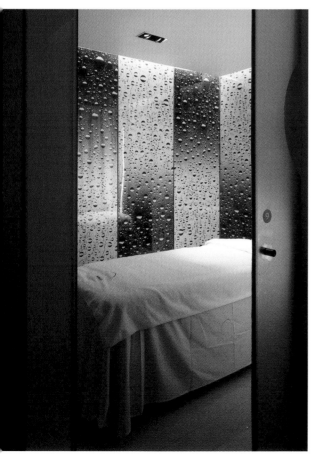

The brief was to give concrete form to the purity suggested by the Evian brand and to emphasize concepts such as transparency, clam and cleanliness. The project also required the integration of the exisiting lobby, which as virtually been turned into a garden. The various spaces are endowed with different atmospheres through the use of delicate textures and soft lighting.

Die Architekten hatten es sich zum Ziel gesetzt, die Reinheit, die die Marke Evian symbolisiert, umzusetzen und durch Transparenz, Ruhe und Klarheit zu unterstreichen. Außerdem musste eine bereits existierende Vorhalle in die Planung miteinbezogen werden, die als eine Art virtueller Garten gestaltet wurde. Die Atomsphäre in den verschiedenen Räumen wird duch ausgewählte Materialen und eine angenehme, indirekte Beleuchtung unterstrichen.

L'objectif consistait à matérialiser la pureté qu'évoque la marque Evian et à mettre en valeur des concepts comme la transparence, le calme et la propreté. Le projet a d'autre part du incorporé le hall existant et l'a fat grâce à un jardin virtuel. L'ambience des différents espaces a été effectuée à partir de délicates textures et aussi grâce à l'éclairage.

El objetivo consistía en materializar la pureza que implica la marca Evian y enfatizar conceptos como transparencia, calma y limpieza. El proyecto preveía, además, la integración del vestíbulo existente, que se incorporó a modo de jardín virtual. La atmósfera de las diferentes estancias se logra a partir de delicadas texturas y con una suave iluminación.

L'obiettivo consisteva nel materializzare la purezza evocata dal marchio Evian e sottolineare concetti quali la trasparenza, la calma e la pulizia. Il progetto prevedeva inoltre l'integrazione dell'atrio già esistente, inglobato come se si trattasse di un giardino virtuale. I vari ambienti assumono atmosfere diverse grazie alle delicate texture e alla tenue illuminazione.

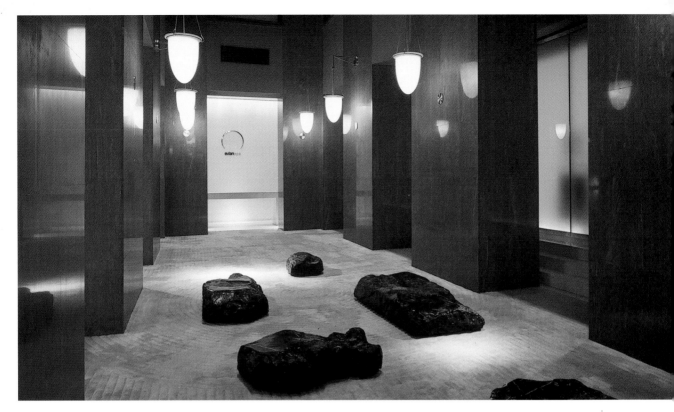

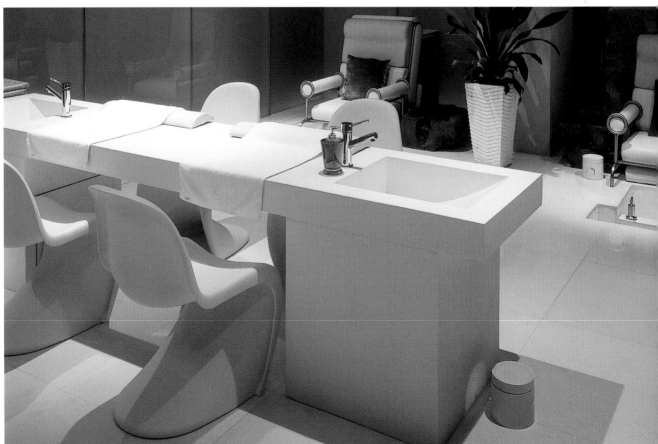

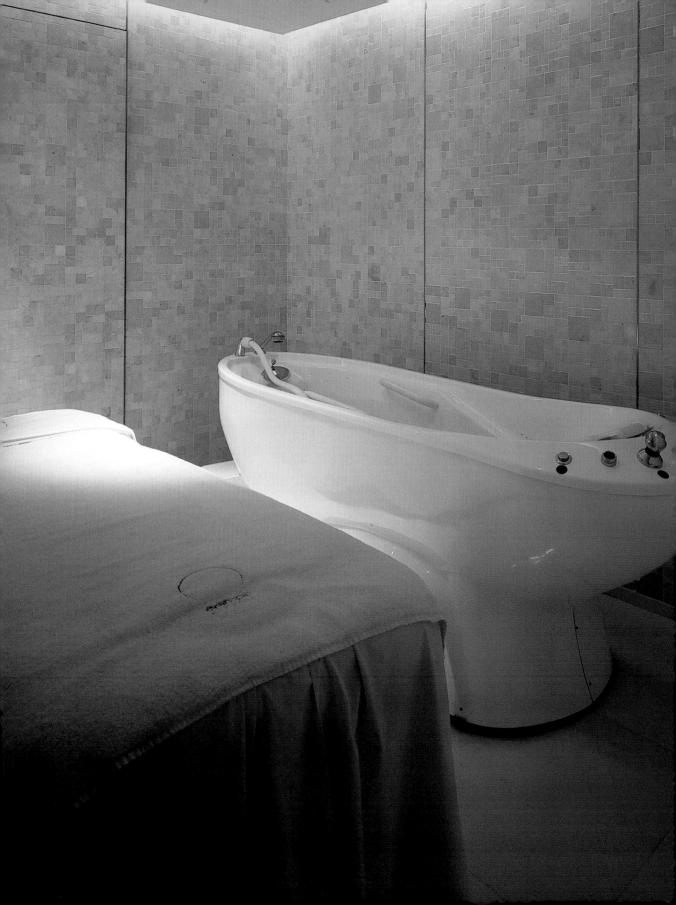

Stretch New York, USA

Architect: Cho Slade Architecture
Photography: Jordi Miralles
601 west 26th street, 16 floor, New York, NY 10001
Phone: +1 212 366 1003
www.stretchnyc.com, info@stretchnyc.com
Services: Pilates, yoga, gyrotonic, contortion, massage, acupuncture

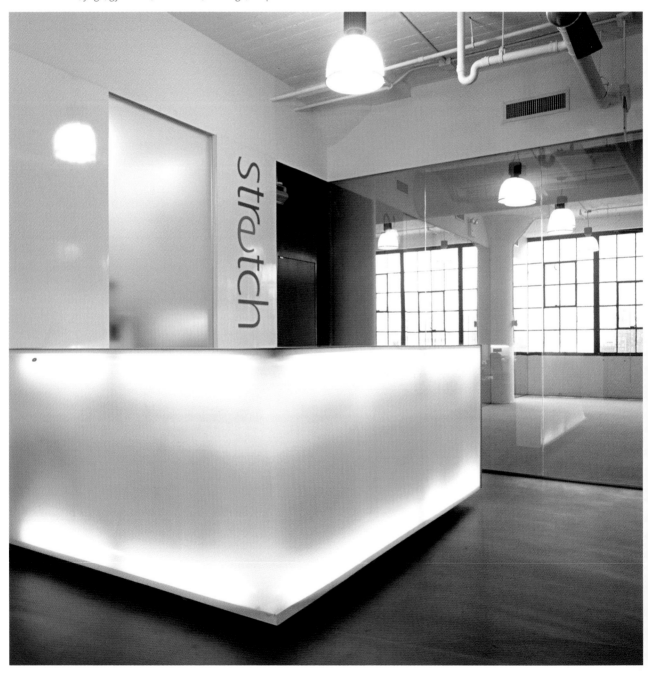

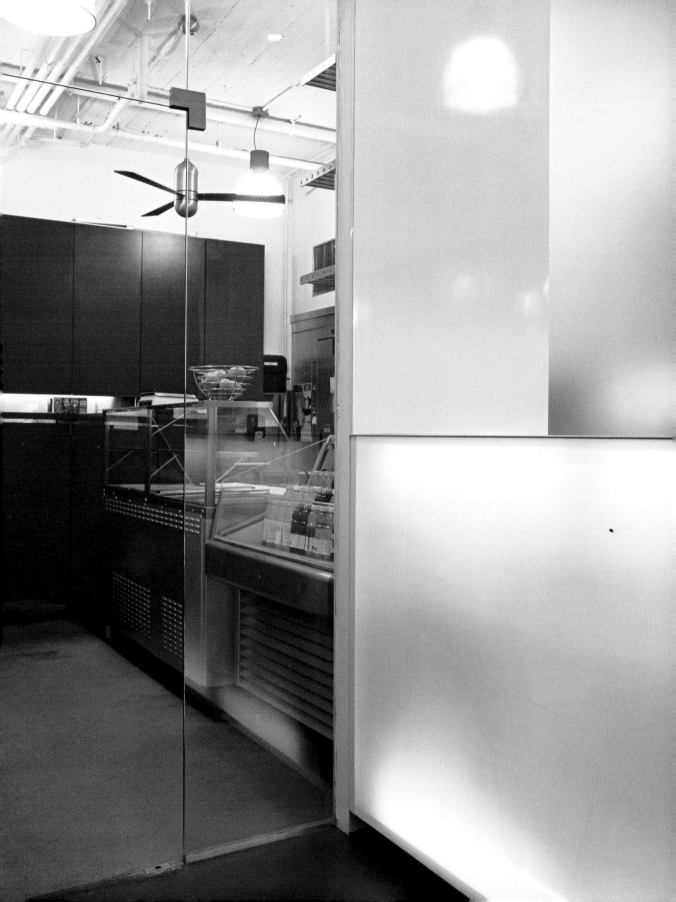

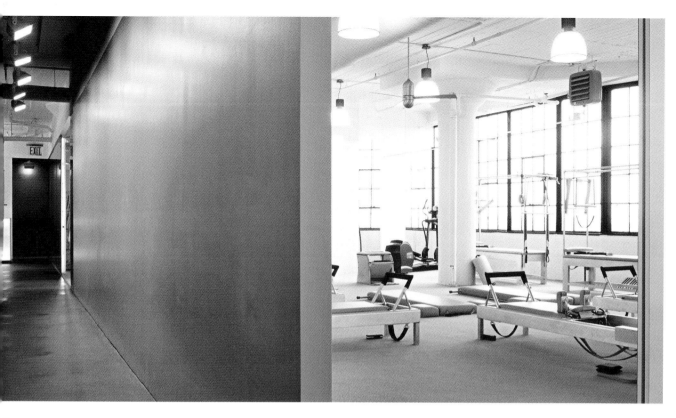

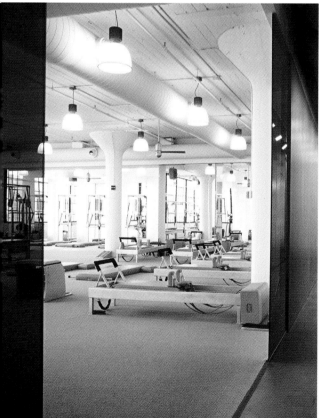

Located in a former warehouse, the spacious, diaphanous interior lacks visual obstacles while natural light pours in through large windows.

Die weiten Räume in diesem ehemaligen Lagerhaus konnten sehr transparent und ohne visuelle Barrieren gestaltet werden. Durch große Fensterflächen strömt viel Tageslicht in die Räumlichkeiten.

Situé dans un ancien entrepôt, l'intérieur spacieux permet de créer des espaces diaphanes, sans entraves visuelles, dotés de grandes verrières laissant la lumière naturelle pénétrer à flots.

Ubicado en un antiguo almacén, la amplitud de su interior permite crear espacios sin obstáculos visuales y diáfanos, ya que la luz natural entra a través de unos grandes ventanales.

L'enorme ampiezza degli interni di questa palestra, originariamente un magazzino, consente di creare degli spazi diafani, senza ostacoli visivi; l'abbondante luce naturale penetra nel locale attraverso i grandi finestroni.

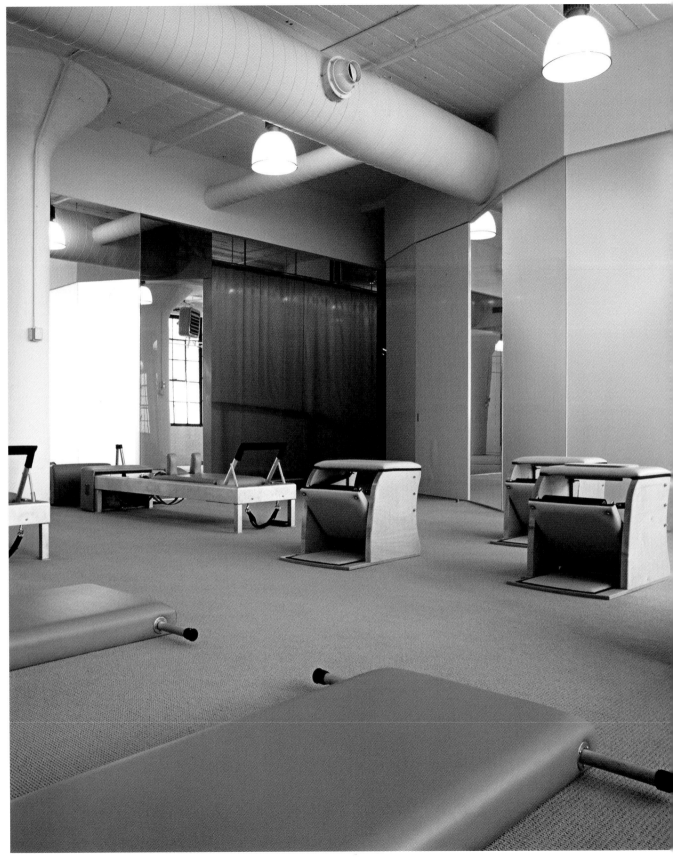

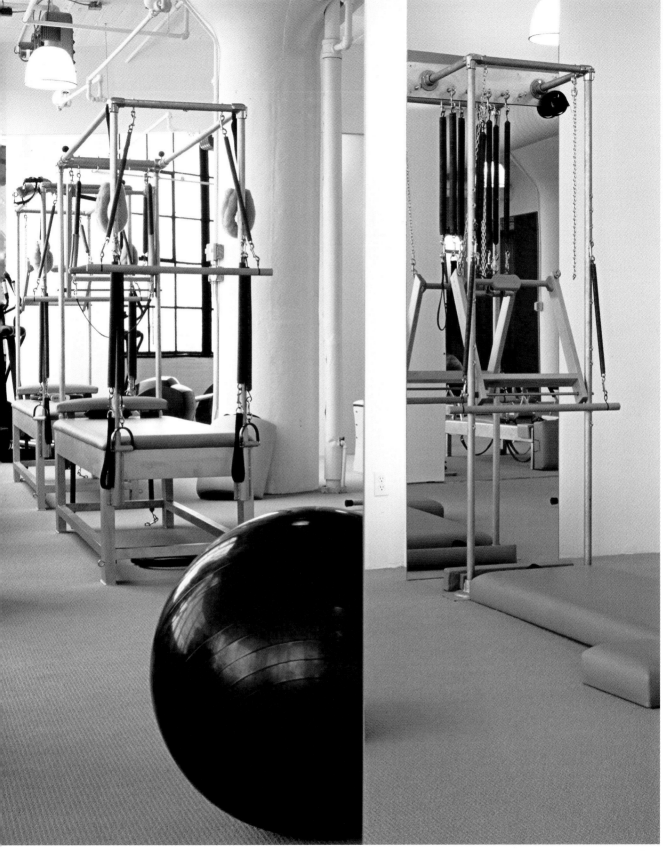

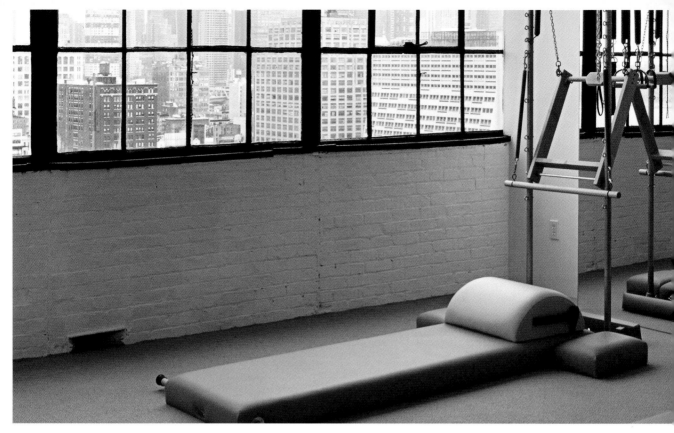

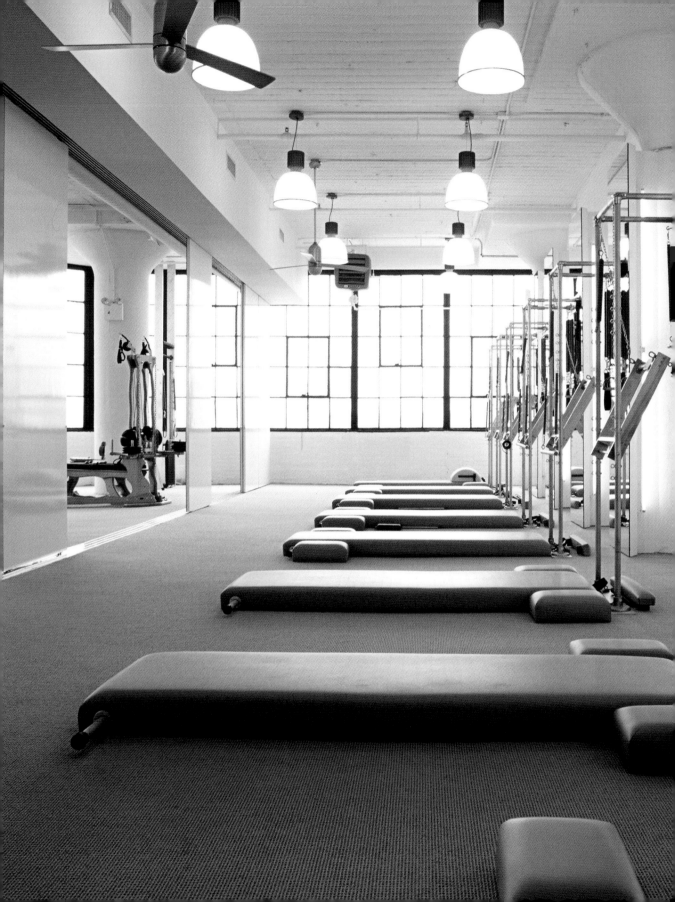

Aurora Spa Retreat Victoria, Australia

Architect: Wood March Architects
Photography: Shania Shegedyn
2 Acland Street, Saint Kilda, Victoria 3182
Phone: +61 3 9536 1130
www.aurorasp03retreat.com
Services: Health and beauty products, yoga, reiki, acupuncture, reflexology, naturopathy, massages

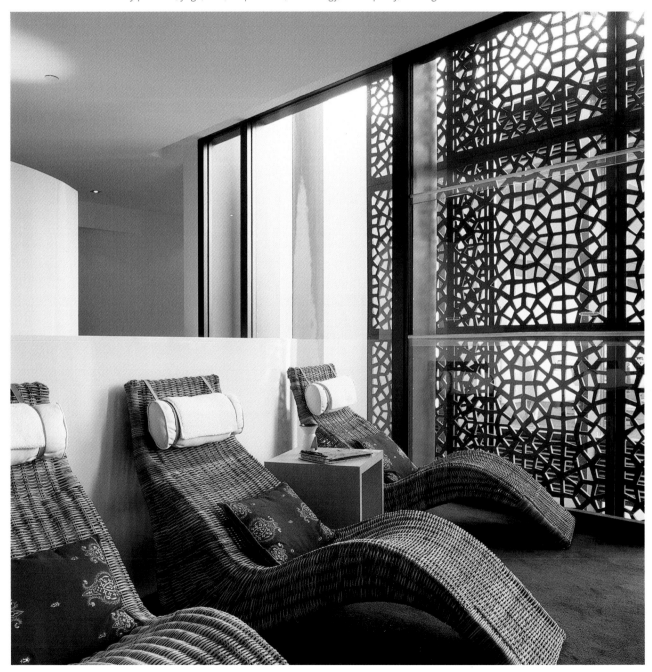

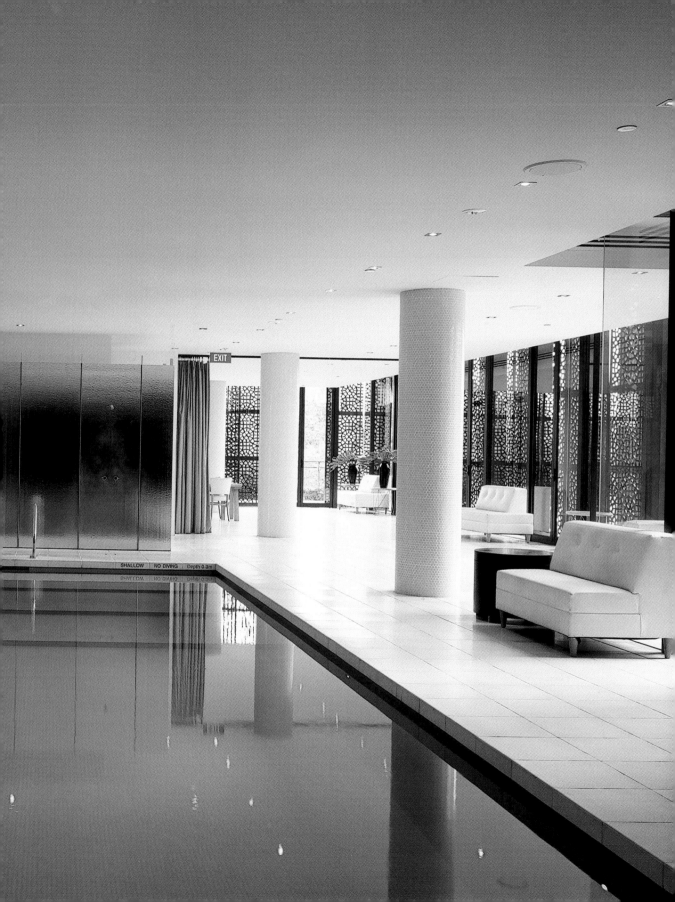

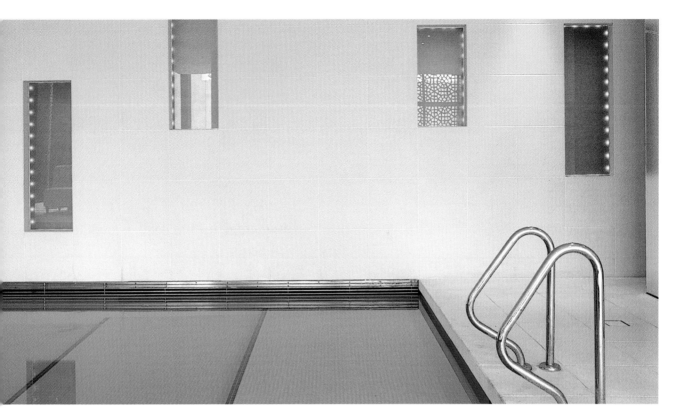

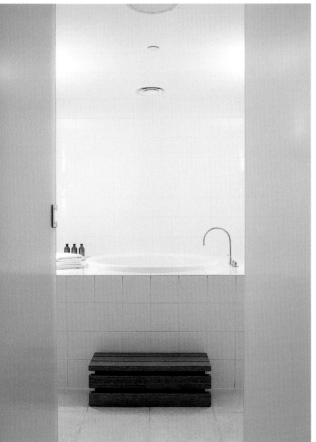

Nestled inside Prince Hotel in St. Kilda, this luxurious spa offers a wealth of unique therapies and treatments based on the natural elements of earth, wind, water and fire. The building is characterized by its latticework façade and large translucent glass doors that lead into the soothing interiors and meditative environment.

Dieses luxuriöse Spa ist im Prinz Hotel in St. Kilda untergebracht und bietet eine Fülle einzigartiger Therapien und Behandlungen an, die auf den Naturelementen Erde, Wasser, Wind und Feuer basieren. Das Gebäude zeichnet sich durch seine Gitterfassade und große Türen aus gefrostetem Glas aus, die in das ruhevolle Innere und in eine meditative Umgebung führen.

Ce spa luxueux, niché à l'intérieur de l'hôtel Prince, à St. Kilda, propose une gamme de thérapies et de traitements basés sur les éléments naturels (terre, vent, eau et feu). L'édifice se définit par une façade de treillis et par de grandes portes translucides qui conduisent vers des intérieurs relaxants et des atmosphères propices à la méditation.

Este lujoso spa, alojado en el interior del hotel Prince, en St. Kilda, ofrece una serie de terapias y tratamientos únicos que se basan en los elementos naturales (tierra, viento, agua y fuego). El edificio se caracteriza por la fachada de enrejado y por las amplias puertas translúcidas que conducen hacia inteiores relajantes y ambientes de meditación.

Questo lussuoso spa, alloggiato all'interno dell'Hotel Prince, a St. Kilda, offre una serie di terapie e trattamenti unici che si basano sugli elementi naturali (terra, vento, acqua e fuoco). L'edificio è caratterizzato dalla facciata coperta da inferriate e dalle ampie porte traslucide che conducono verso interni rilassanti e ambienti di meditazione.

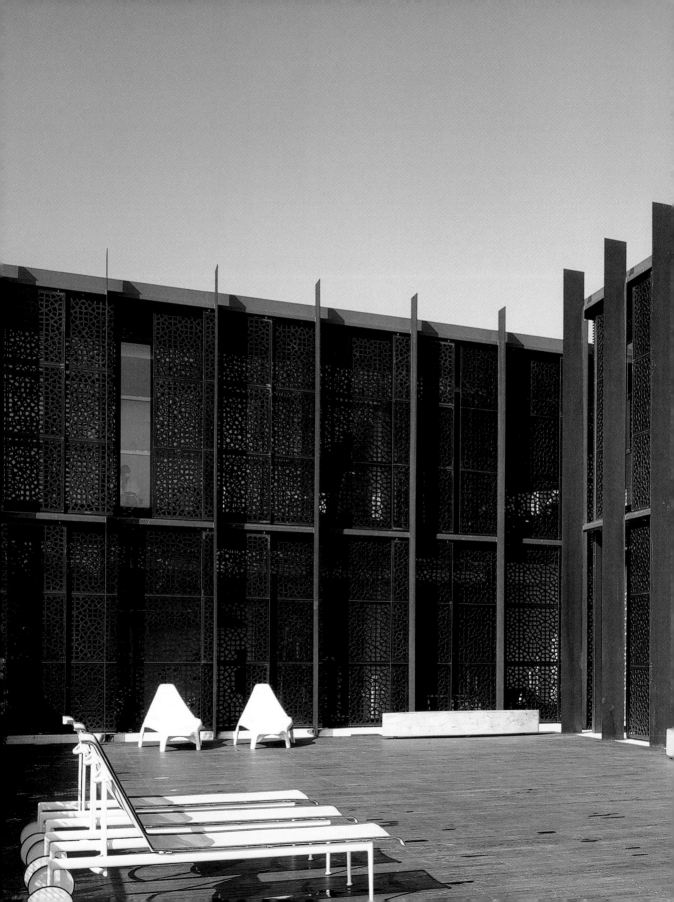

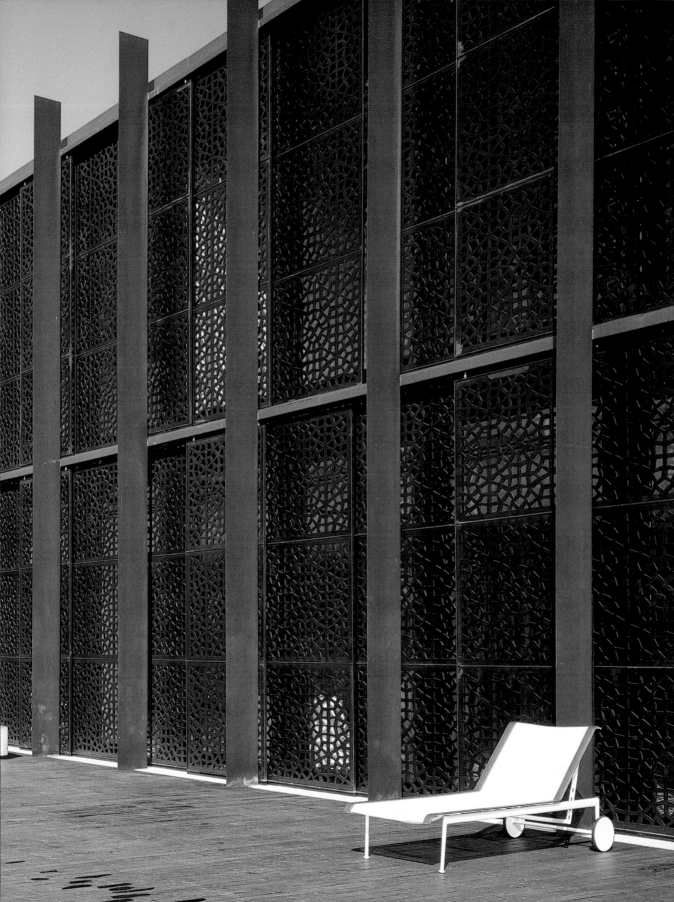

W Mexico City Mexico DF, Mexico

Architect: Studio Gaia
Photography: Studio Gaia
Campos Elíseos 252, Mexico DF 11560
Phone: +52 9138 1800
www.whotels.com, mexicocity@whotels.com
Services: Health club and spa-wellness center, sun room, jacuzzi

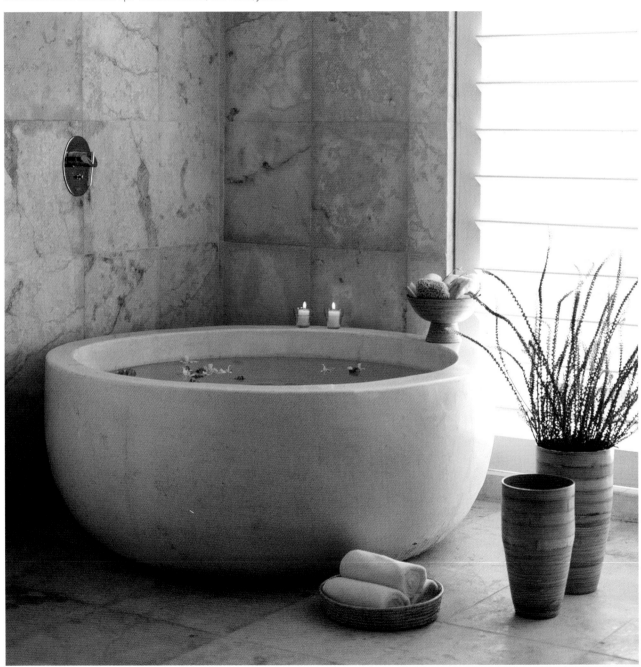

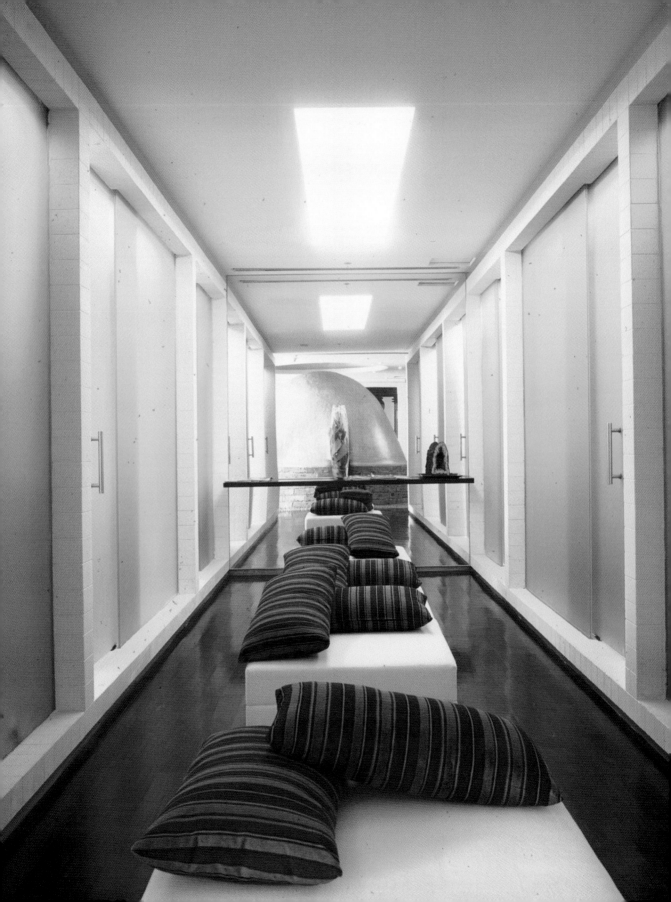

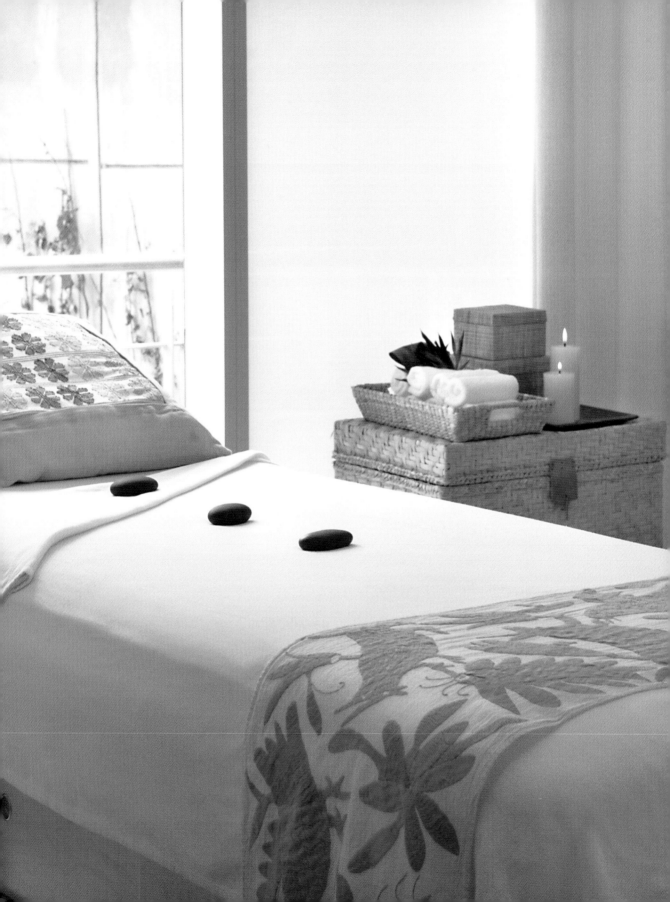

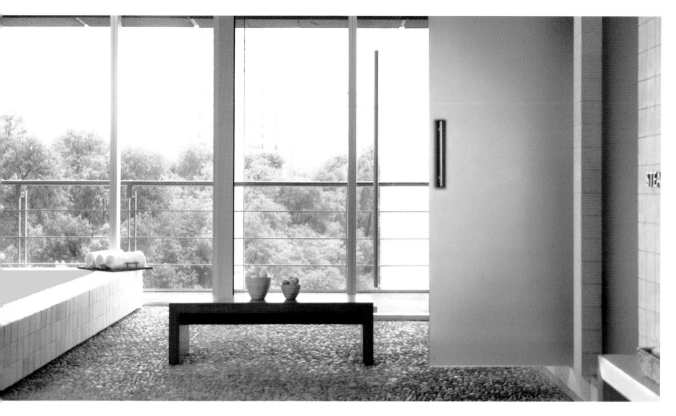

The design combines local elements and the latest trends from New York, where the design studio responsible for the project is located.

Bei der Gestaltung dieser Räume kombinierte man einheimische Elemente mit moderneren Trends aus New York, wo sich das Designstudio befindet, das diese Räume gestaltet hat.

L'esthétique du design conjugue éléments autochtones et tendances les plus modernes venant de New-York, ville d'origine du studio de design chargé de la réalisation du projet.

La estética del diseño conjuga elementos autóctonos y las tendencias más modernas procedentes de Nueva York, ciudad en la que se encuentra el estudio de diseño que ha realizado el proyecto.

L'arredamento coniuga elementi autoctoni e le tendenze più moderne attualmente in voga a New York, città in cui si trova lo studio di design che ha realizzato il progetto.

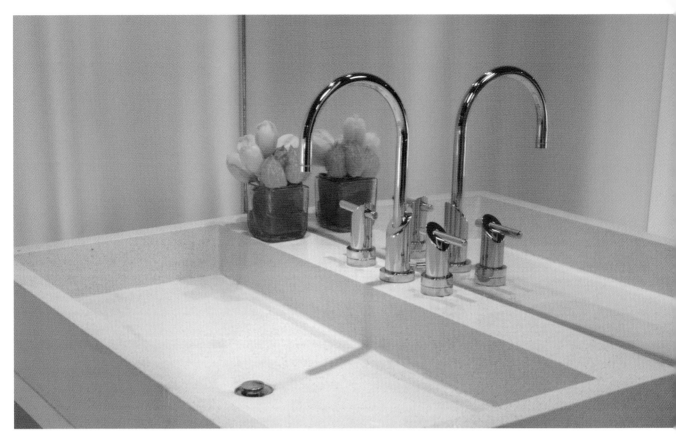

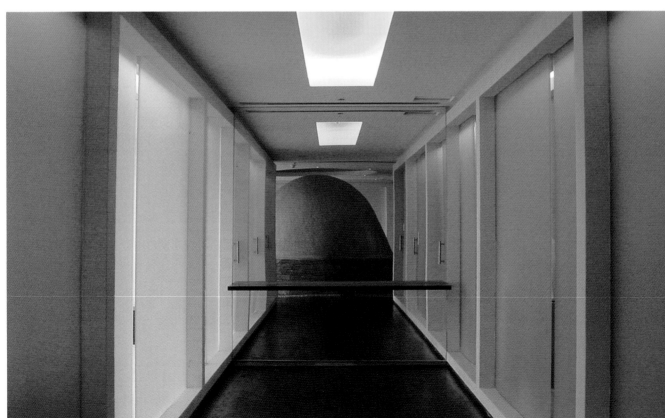

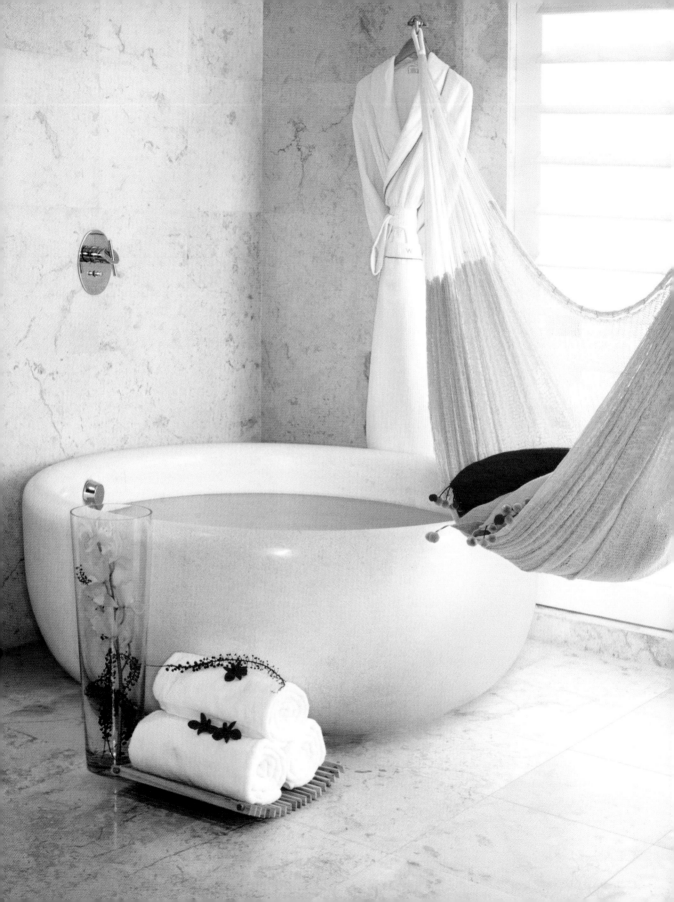

Geibeltbad Pirna Pirna, Germany

Architect: Arnke und Häntsch Architekten
Photography: Werner Huthmacher
Rottwerndorfer Straße 56c, 01796 Pirna
Phone: +49 3501 710 900
www.geibeltbad-pirna.de, geibeltbad@stadtwerke-pirna.de
Services: Aquatic area and games, giant slide, olympic pool, shallow pool, sauna, camping, organized events

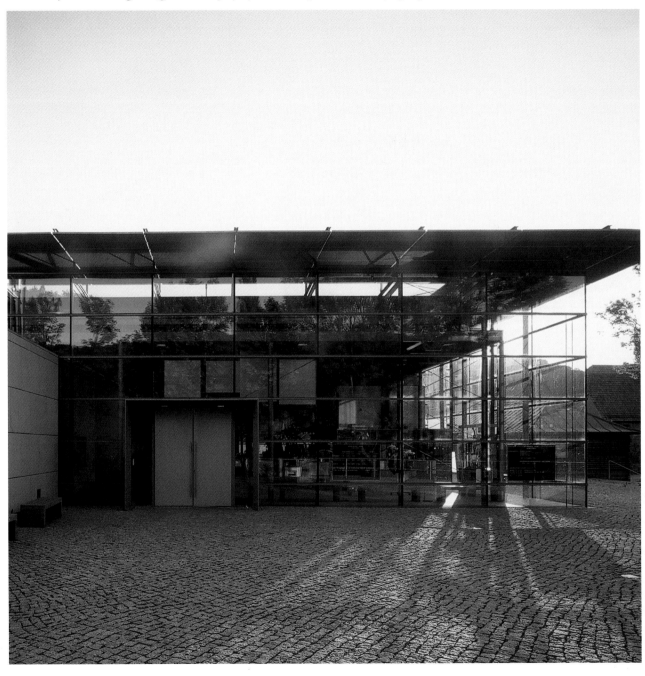

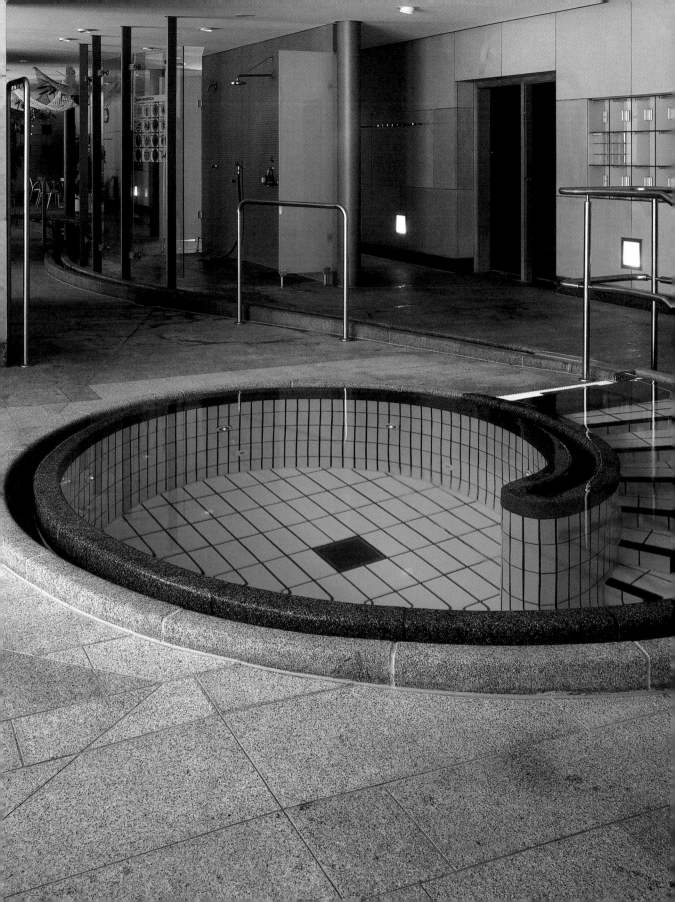

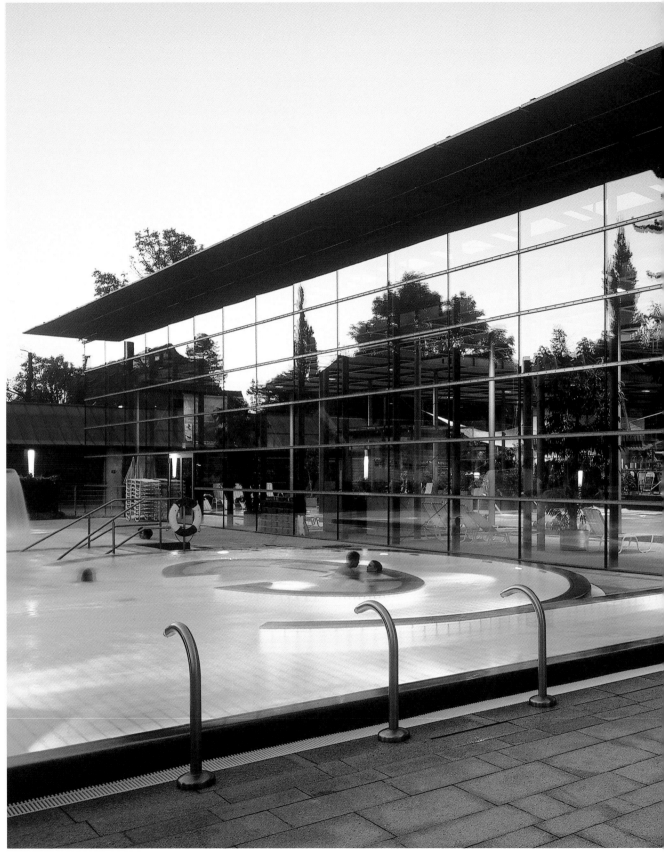

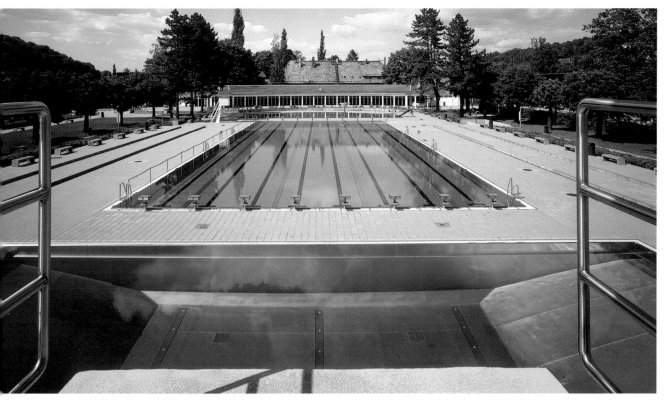

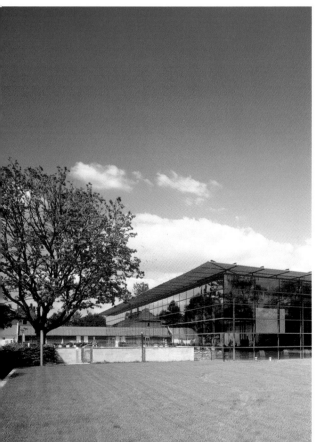

The spa is located in Pirna, a small city belonging to the German Saxony on the shores of the Elba River and surrounded by steep mountains. The interior and exterior pools that make up the complex integrate with the surroundings thanks to its organization, emplacement, and its incorporation of local materials.

Das Freizeitbad liegt in Pirna, einer kleinen Stadt in der sächsischen Schweiz am Ufer der Elbe, umgeben von steilen Berghängen. Die Innen- und Außenbecken des Komplexes harmonisieren mit dem Umfeld, zum einen durch die Organisation und Anordnung des Gebäudes, als auch durch die Verwendung lokaler Materialien.

La station balnéaire est située à Pirna, dans un village de Saxe allemande au bord de l'Elbe, entouré de montagnes escarpées. Le complexe de piscines couvertes et découvertes de la station balnéaire s'intègre au paysage, tant par l'organisation et l'emplacement du site dans la topographie, que par l'emploi de matériaux locaux.

El balneario está ubicado en Pirna, una población de la Sajonia alemana a orillas del río Elba rodeada de escarpadas montañas. El conjunto de piscinas cubiertas y al aire libre que constituyen el balneario armonizan con el entorno, tanto por su organización y emplazamiento en la topografía, como por los materiales locales utilizados.

Il centro di benessere si trova a Pirna, una località della Sassonia tedesca situata sulle sponde dell'Elba e circondata da scoscese montagne. L'insieme di piscine coperte e scoperte che formano parte del centro si integrano nel paesaggio grazie alla loro situazione e disposizione, nonché all'uso di materiali locali.

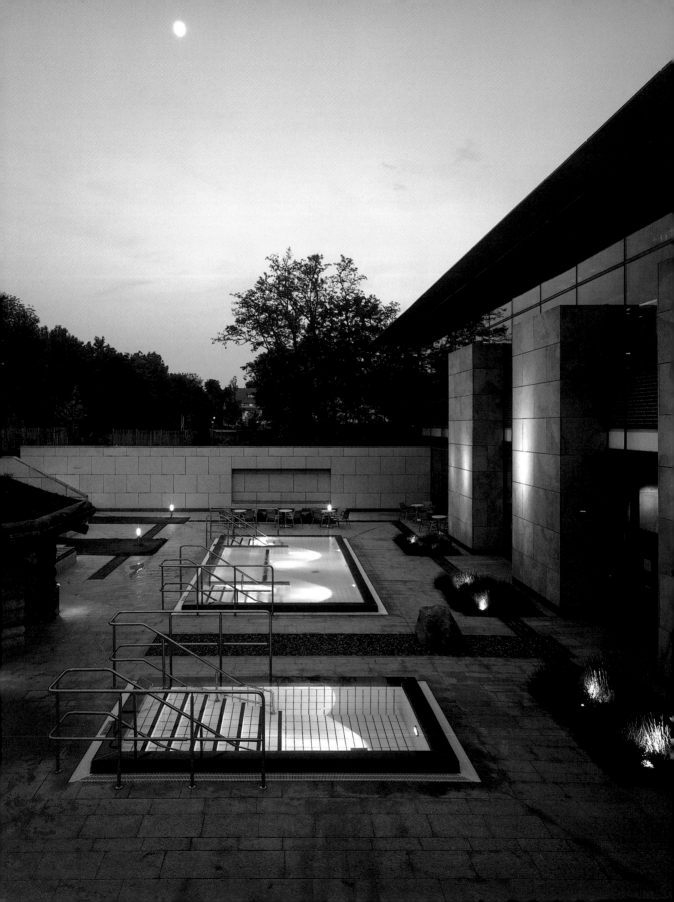

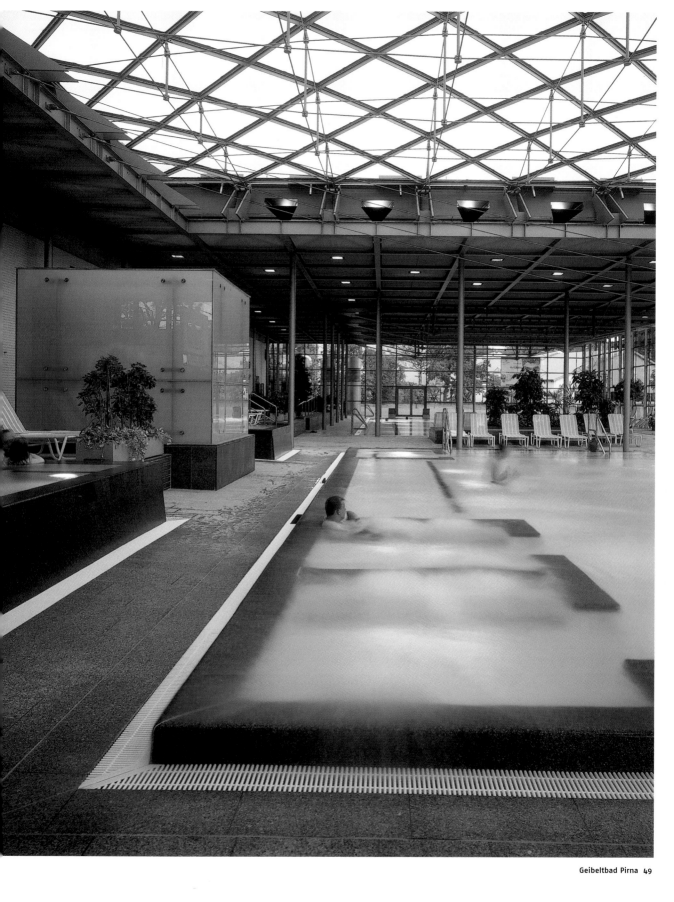

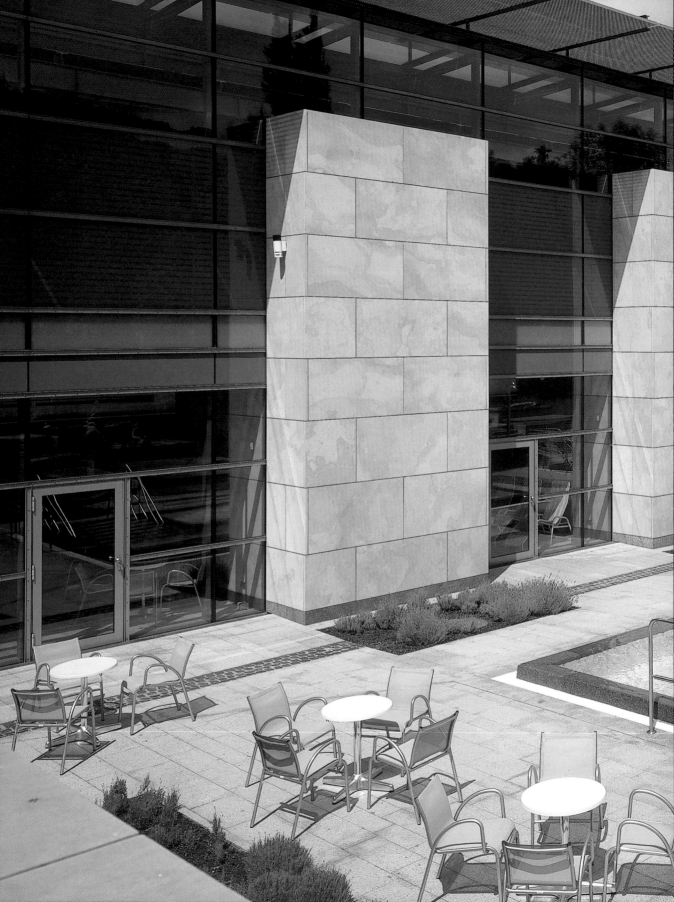

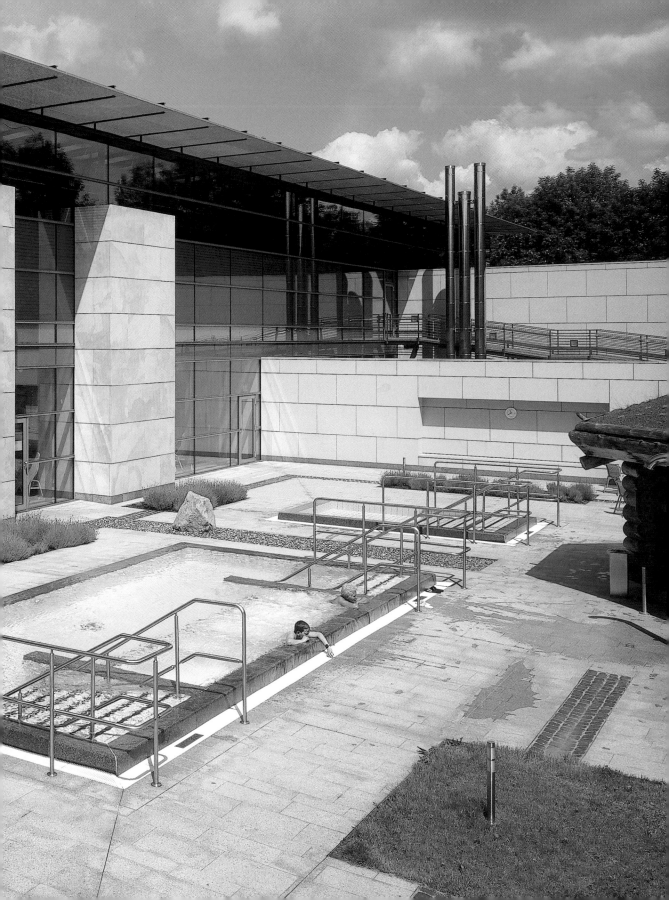

Holmes Place Wien Börseplatz Vienna, Austria

Architect: ORMS Achitects + Designers
Photography: Eric Laignel
Wipplingerstraße 30, 1010 Vienna
Phone: +43 01 533 97 90 90
www.holmesplace.com
Services: Pilates, tai-chi, yoga, body shape, massages, beauty treatments

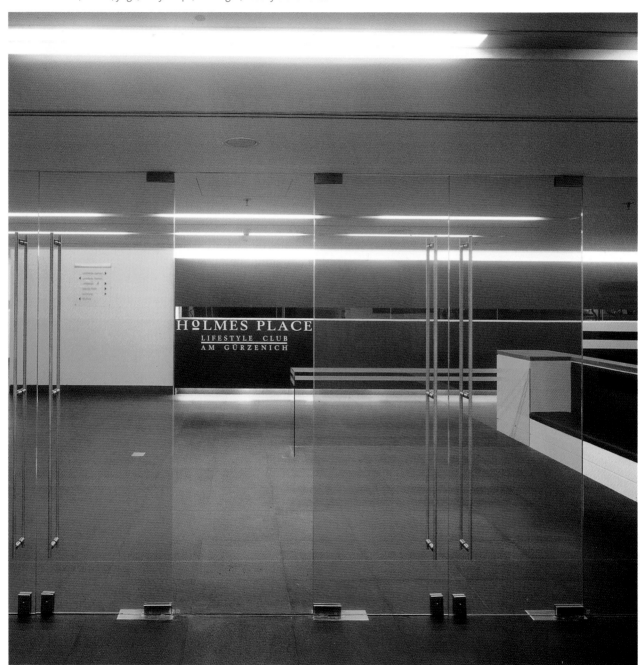

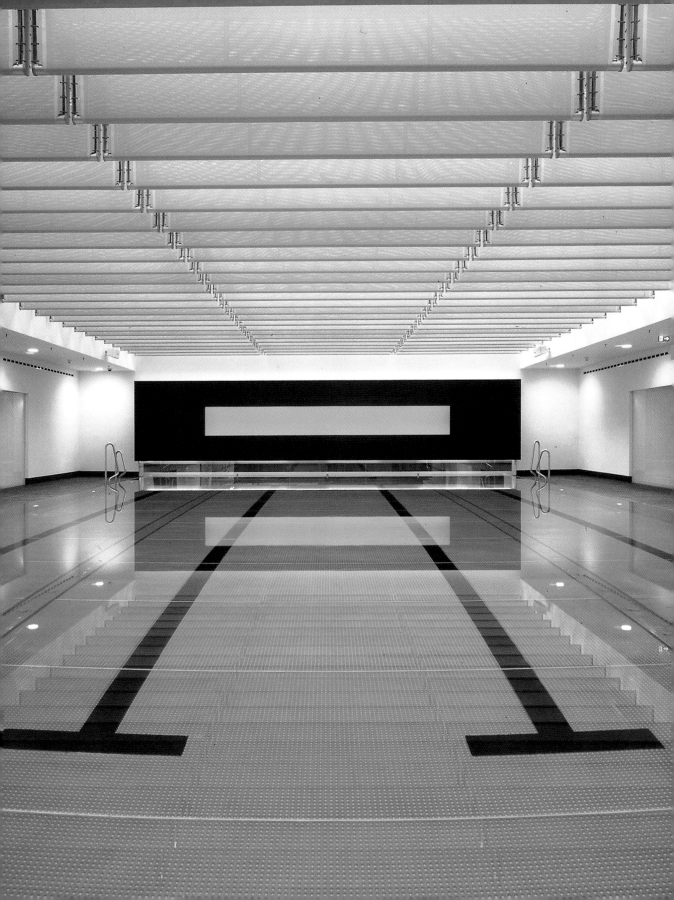

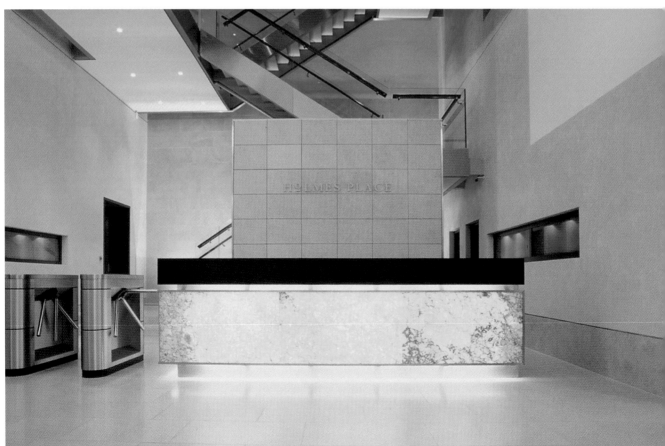

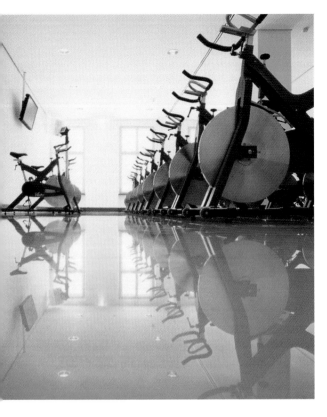

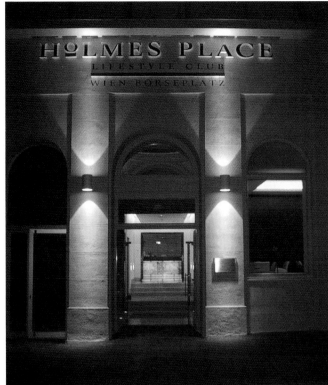

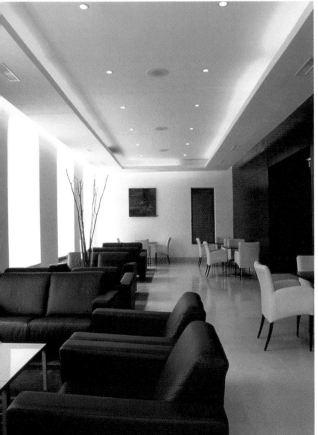

Located in the central district of Vienna, this 42,000 square foot health club incorporates a new structure behind a nine-story, 19th century façade. In order to respect the essence of the building, the exterior makes references to the original structure, the choice of materials, and in the processional transition from street to interior.

Dieses 4000 m² große Fitnesscenter im Zentrum Wiens verbirgt sich hinter der Fassade eines neunstöckigen Bauwerkes aus dem 19. Jahrhundert. Durch die Materialauswahl, die Fassadengestaltung und dem Übergang zwischen Empfang und Straße, wurde dem Charakter des Gebäudes Respekt gezollt.

Ce centre de santé d'une superficie de près de 4000 m², situé au cœur de Vienne, déploie sa nouvelle structure derrière une façade de neuf étages datant du XIXe siècle. Le choix des matériaux et du revêtement extérieur de l'édifice, comme la transition entre l'extérieur et l'intérieur, font allusion à la structure originale pour conserver le caractère de l'édifice.

Este centro de salud de casi 4000 m², ubicado en el centro de Viena, presenta una nueva estructura detrás de la fachada de nueve pisos del siglo XIX. Con el fin de respetar su esencia, se hizo alusión a la estructura original en la piel del edificio, en la elección de los materiales y en la transición entre el exterior y el interior.

Questo centro di benessere di quasi 4000 m², situato nel centro di Vienna, presenta una nuova struttura nascosta dietro la facciata di nove piani del secolo XIX. Allo scopo di rispettarne l'essenza, si è fatta allusione alla struttura originale nella pelle dell'edificio, nella scelta dei materiali e nella transizione tra l'interno e l'esterno.

LA Fitness Victoria London, England

Architect: SHH Architects
Photography: Francesca Yorke
Portland House, Stag Place, London SW 1E 5BH
Phone: +44 0870 224 5471
www.lafitness.co.uk
Services: Spa, fitness, squash, gym, LA spin, sauna, pool, aerobics, sunbeds, beauty and alternative treatments, physiotherapy

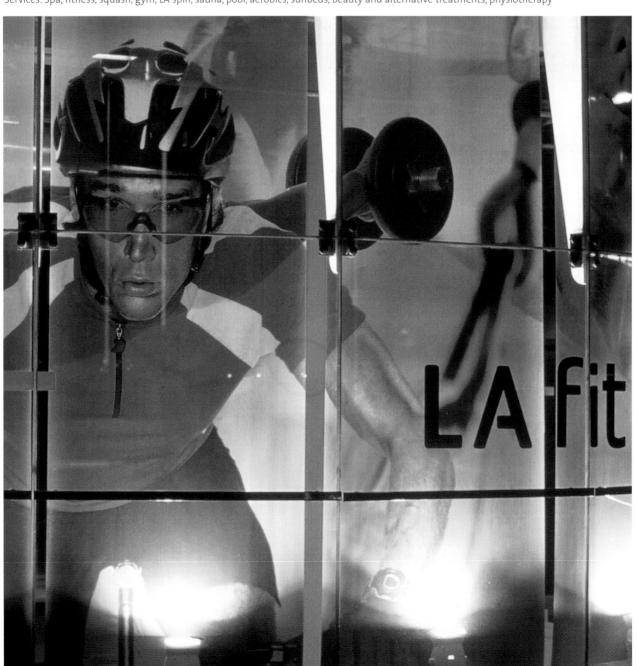

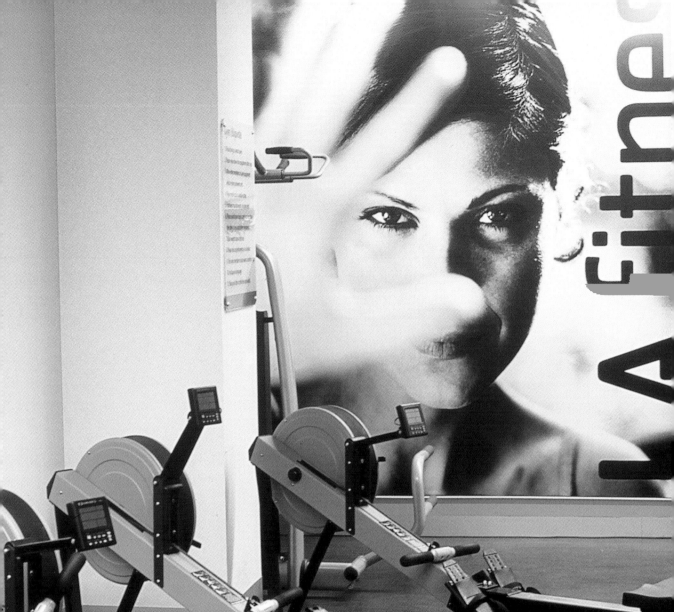

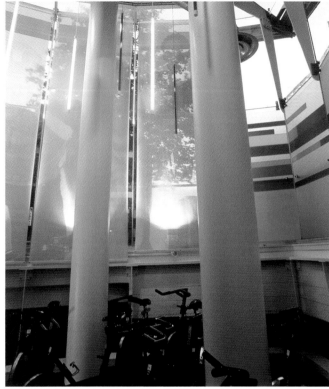

The new extension of this center is almost entirely located in the basement, access to which is by means of two entrances on the ground floor, the first of which stands out by virtue of its striking colors.

Die neuen Bereiche dieses Zentrums befinden sich fast alle im Keller des Gebäudes. Es wurden zwei Eingänge im Erdgeschoss geschaffen, der erste fällt durch die kräftigen Farben, die verwendet wurden, auf.

L'extension récente de cet établissement occupe, en grande partie, le sous-sol de l'édifice. Deux entrées construites au rez-de-chaussée permettent d'y accéder, la première des deux se détachant pour son impact chromatique marqué.

La nueva extensión de este local se ubica, prácticamente toda, en el sótano del edificio. Para acceder a él se han construido dos entradas en la planta baja y la primera de ellas destaca por una gran fuerza cromática.

La nuova zona, frutto dell'ampliamento di questo locale, occupa quasi interamente il piano interrato dell'edificio. Per accedervi sono stati costruiti al piano terra due ingressi; il primo di questi spicca per la sua grande forza cromatica.

LA Fitness Finchley London, England

Architect: SHH Architects
Photography: Francesca Yorke
East End Road, Finchley, London N3 2TA
Phone: +44 0870 607 2138
www.lafitness.co.uk
Services: Fitness, sauna, massage, spa, pool, aerobics, beauty and alternative treatments, gym, physiotherapy, LA spin, sunbeds

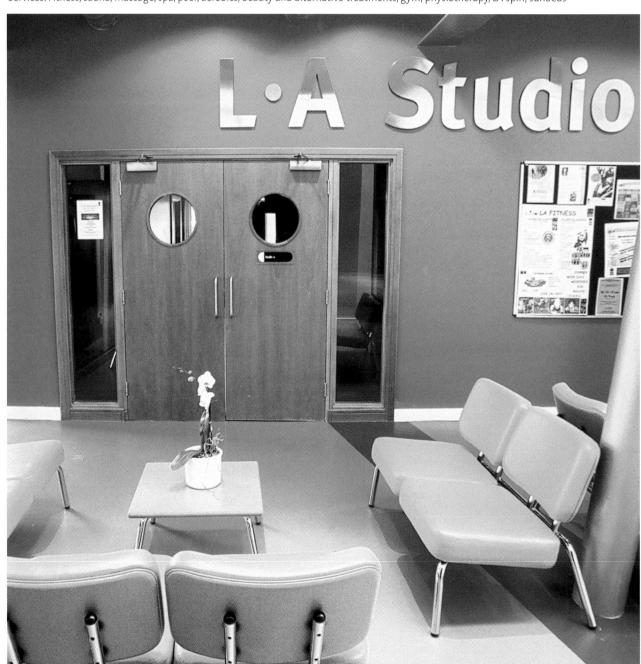

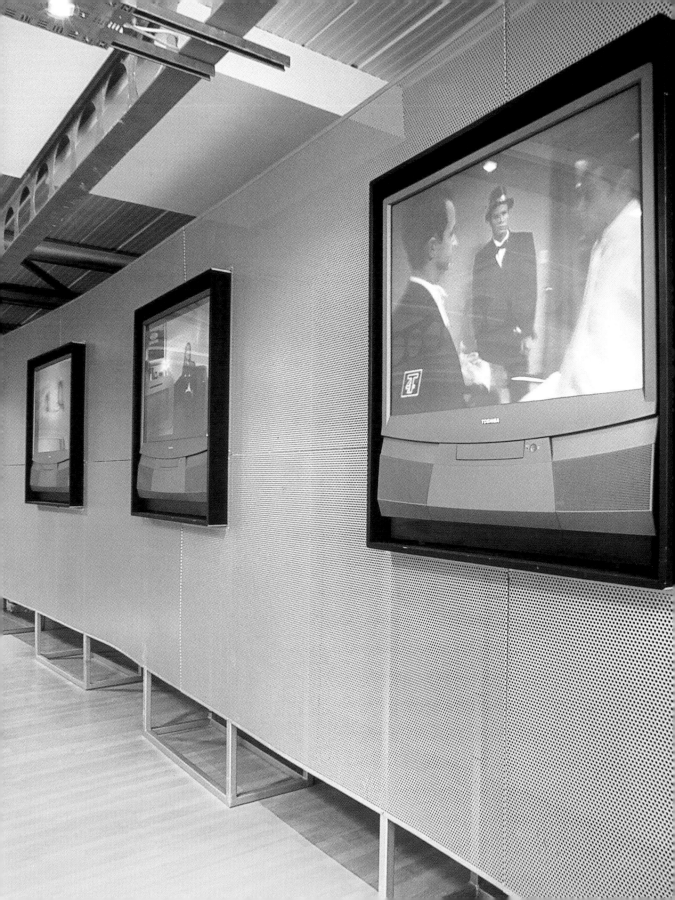

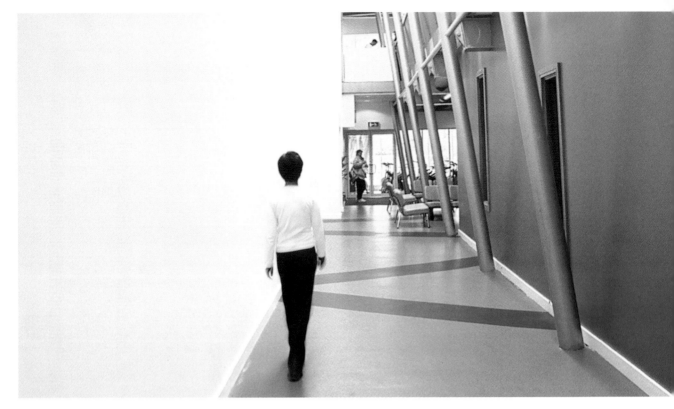

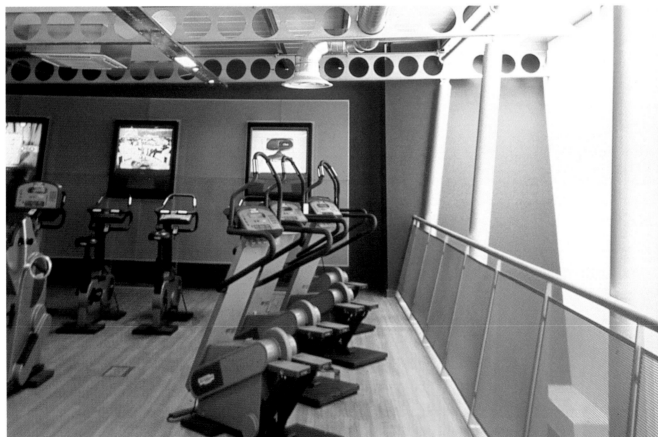

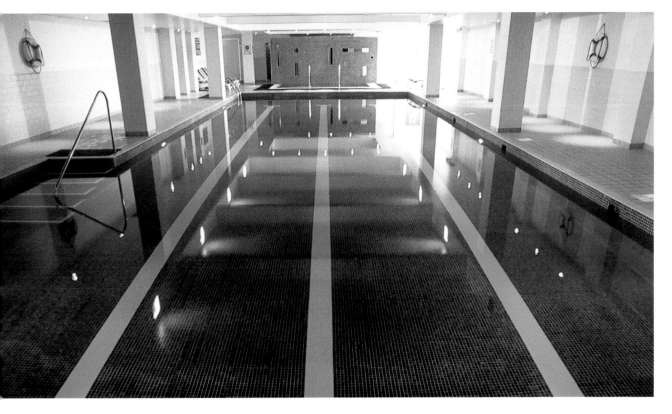

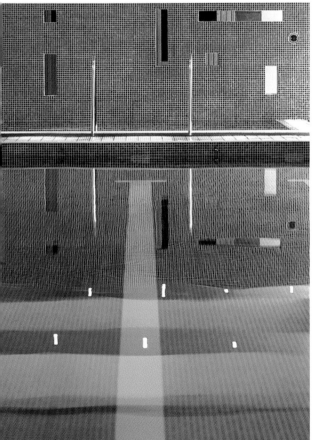

The bold design clearly goes for modernity through the use of bright colors to delimit the different areas.

Die gewagte Raumgestaltung setzt eindeutig auf Modernität. Es wurden kräftige Farben benutzt, um die verschiedenen Bereiche zu unterscheiden.

Le design audacieux affiche clairement son modernisme grâce à l'emploi de couleurs vives pour délimiter les différentes zones.

El diseño es audaz y apuesta claramente por la modernidad mediante el empleo de colores vivos para delimitar las distintas áreas.

Il design ardito punta decisamente sulla modernità e l'uso di colori vivi per delimitare le varie zone.

Fitness Hotel Rey Juan Carlos I Barcelona, Spain

Architect: Josep Mª Cartañà
Photography: Jordi Miralles
Avenida Diagonal 661-671, 08028 Barcelona
Phone: +34 93 364 40 40
www.hrjuancarlos.com, hotel@hrjucancarlos.com
Services: Line dance, tai-chi, chi kung, aero-jazz, aero-styles, steps, basic gym, chocolate, honey and volcanic hot stones massages

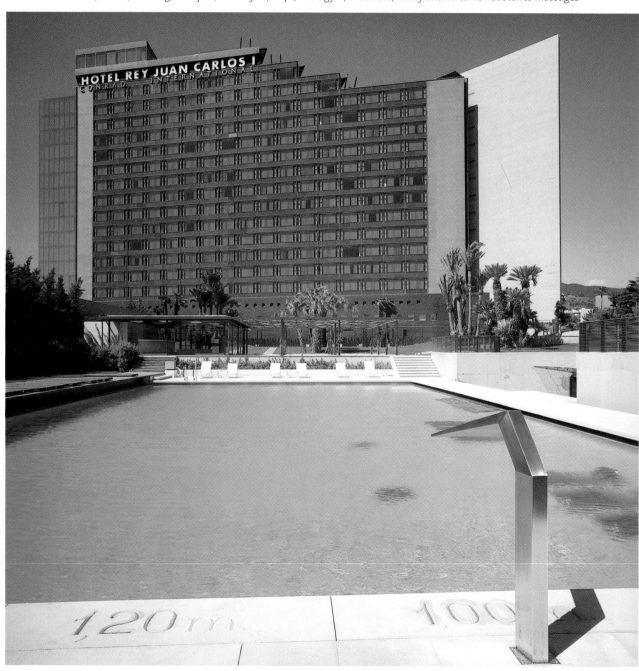

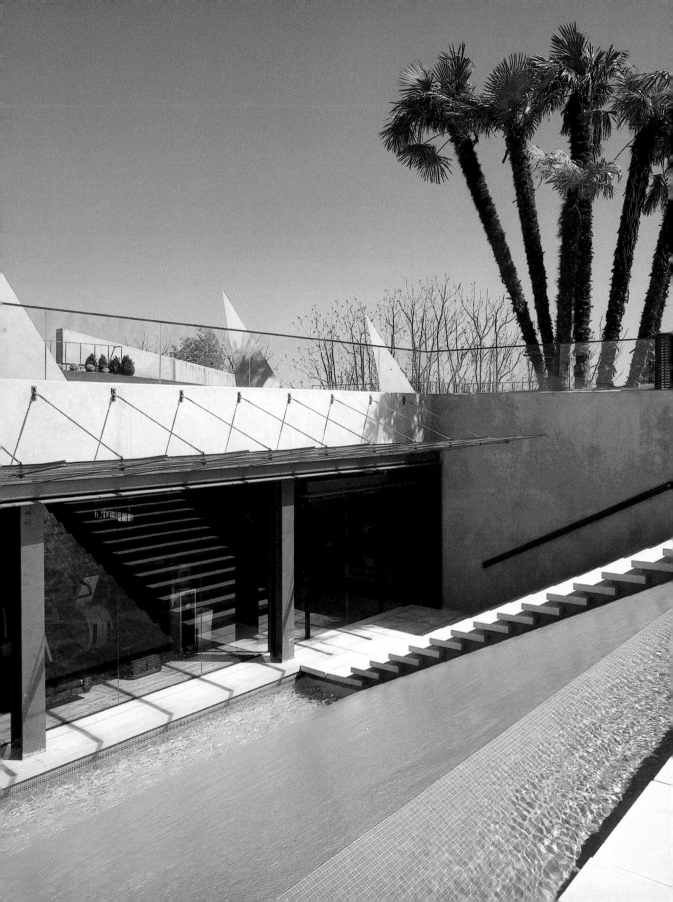

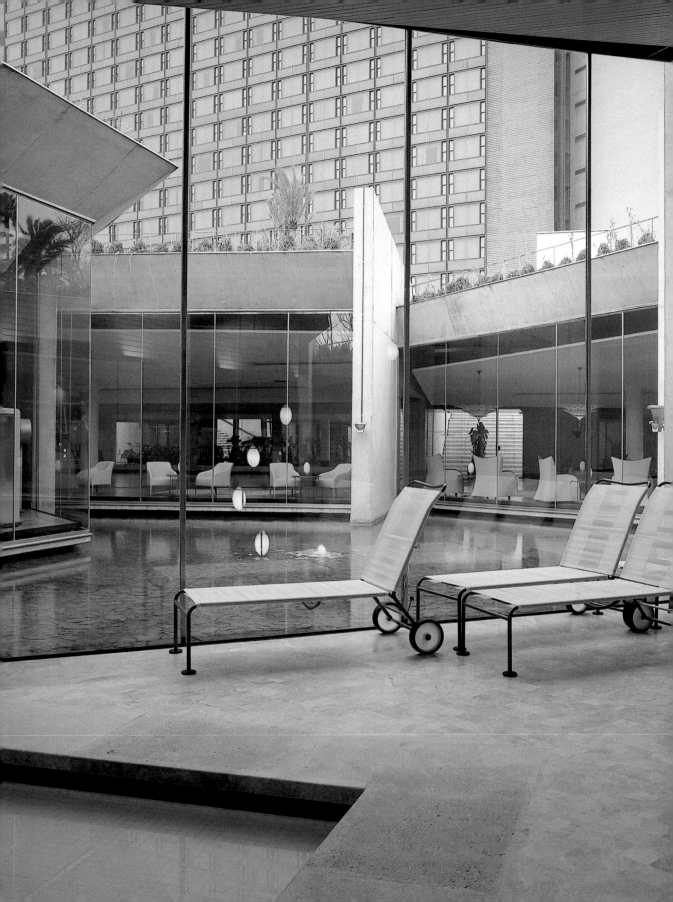

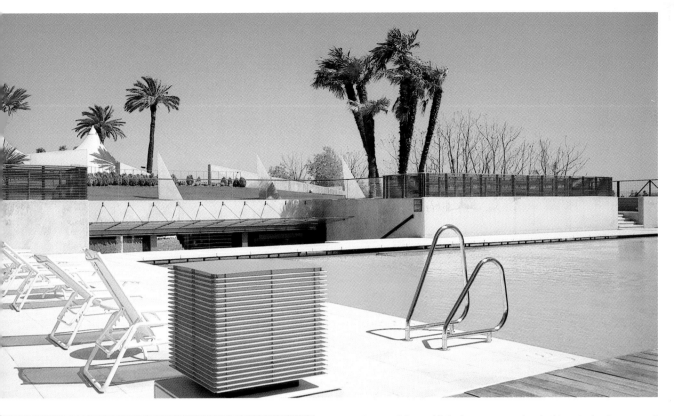

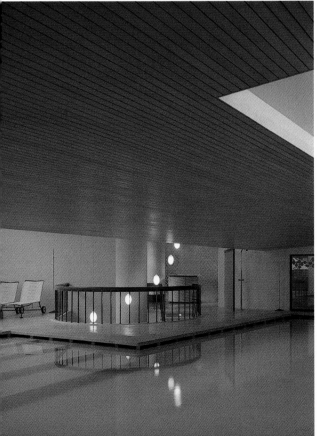

Located in one of the world's leading convention hotels, this center has been named Leading Spa 2005 and its design is characterized by elegance and sophistication.

Dieses Fitnesscenter befindet sich in einem international führendem Tagungshotel und wurde zum Leading Spa 2005 ernannt. Die Gestaltung zeichnet sich durch ihre Eleganz und Raffinesse aus.

Situé dans un des hôtels de congrès de renommée internationale, ce centre, au design élégant et subtil, a été nommé Leading Spa 2005.

Ubicado en uno de los hoteles de convenciones de alto nivel con mayor prestigio internacional, ha sido nombrado Leading Spa 2005 y su diseño se caracteriza por la elegancia y la sofisticación.

Questo fitness center, situato all'interno di uno dei più prestigiosi alberghi per congressi e convention a livello internazionale, è stato eletto Leading Spa 2005. Il suo design è elegante e sofisticato.

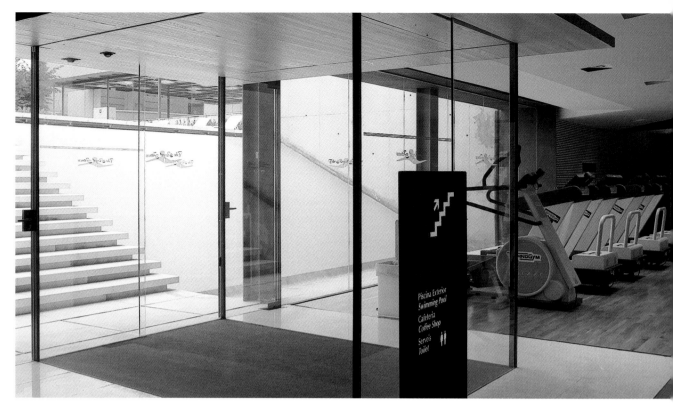

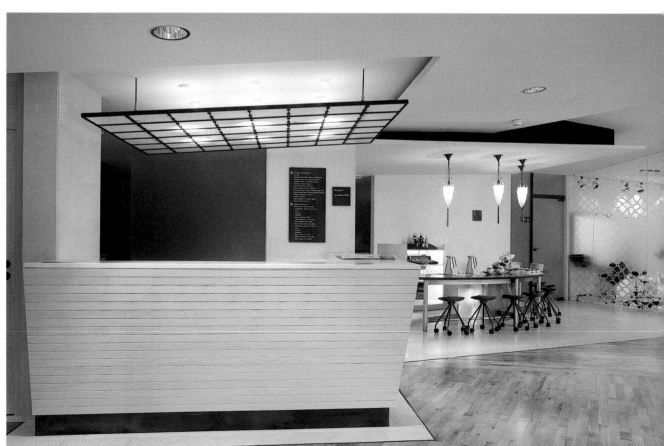

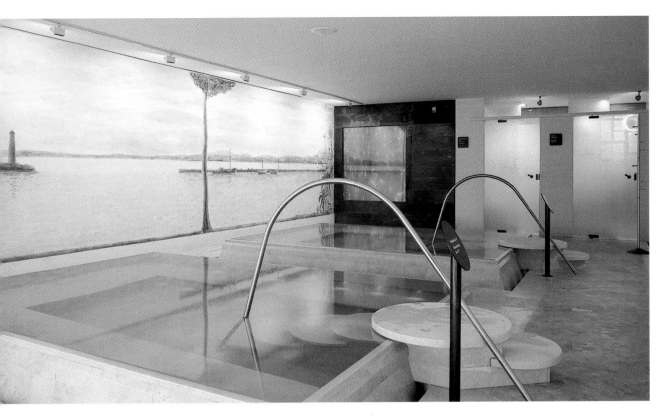

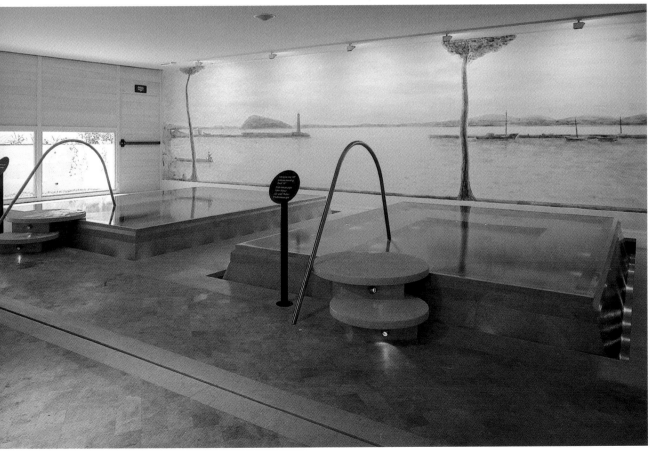

Blissful Milan, Italy

Architect: Marco Savorelli
Photography: Matteo Piazza
Via Unione, 1, 20122 Milan
Phone: +39 02 89012820
www.blissfulclub.it, info@blissfulcenter.it
Services: Low-calories cuisine, spa peeling, shiatsu, solarium, turkish bath, massage, aesthetic and therapeutic pedicure

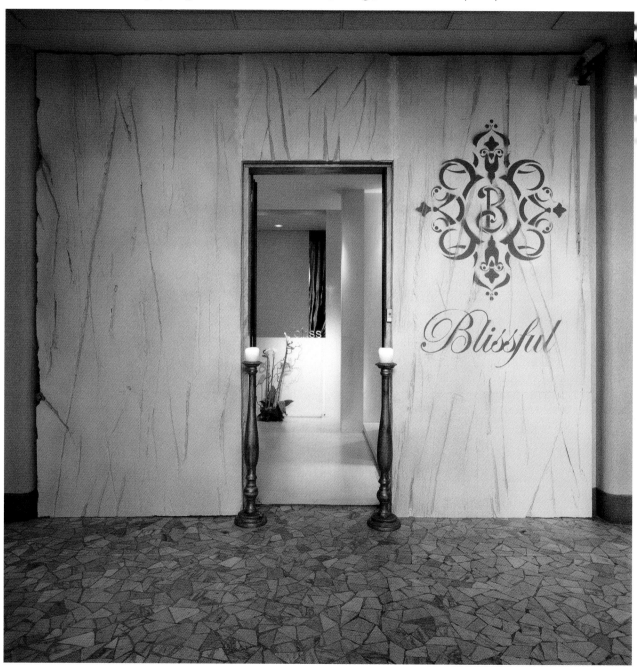

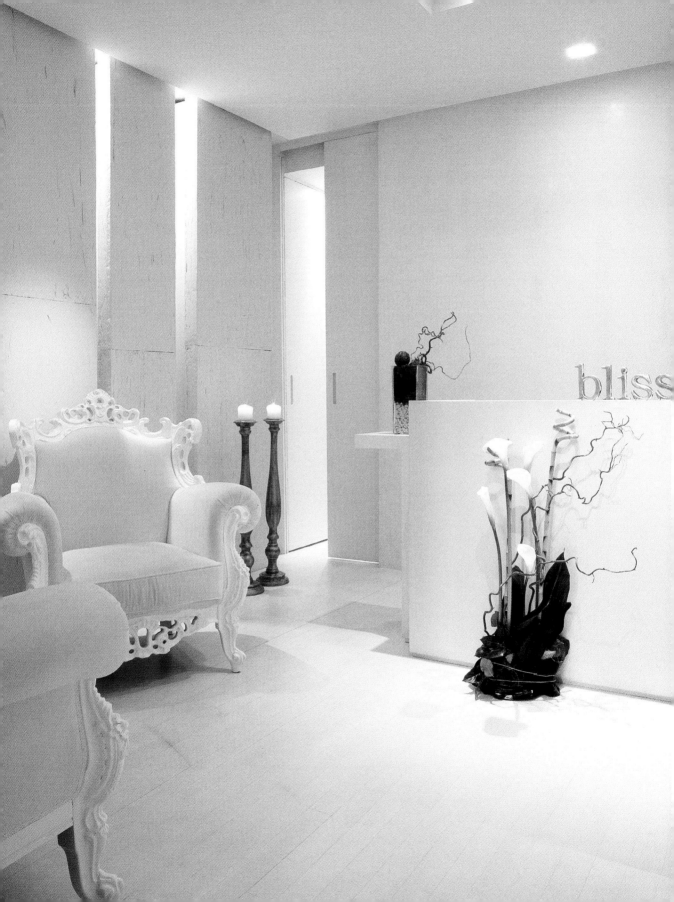

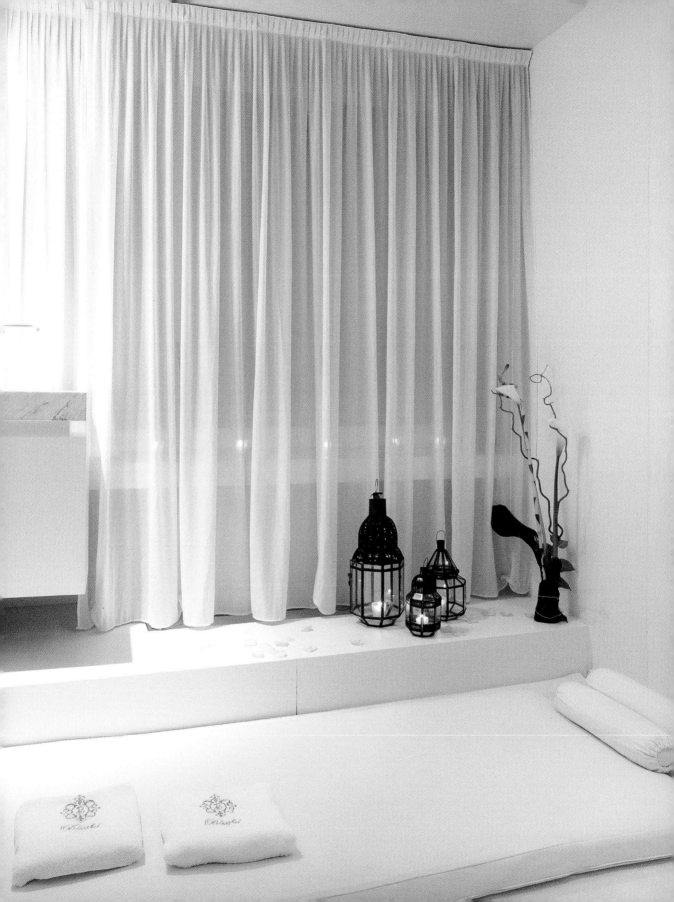

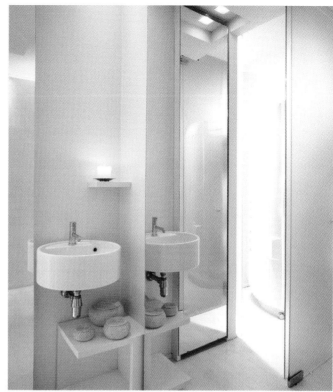

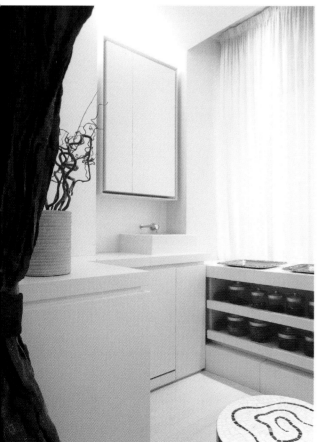

The design of this center creates a private space for relaxation in the midst of the city's hubbub. The abstract nature of the container is the prevailing concept, as if light itself creates the material and gives it life.

In diesem Studio schuf man eine intime und entspannte Atmosphäre, eine Oase in der Hektik der Stadt. Das grundlegende Gestaltungskonzept ist die Abstraktion der Umhüllung, so als ob das Licht die Materie gestaltet und ihr Leben einflößt.

Le design de ce centre crée un espace intime et relaxant au cœur de l'agitation intense de la ville. L'abstraction de la structure est l'essentiel du concept : la lumière semble façonner la matière et la faire vivre.

El diseño de este centro crea un espacio íntimo y de relajación en medio de la intensa actividad de la ciudad. La abstracción del envoltorio es el concepto principal, como si la luz plasmase la materia y la hiciera viva.

L'arredamento di questo centro crea uno spazio intimo e di relax che contrasta con l'intensa e frenetica attività urbana dell'esterno. L'astrazione dell'involucro è il concetto principale, come se la luce plasmasse la materia e la facesse viva.

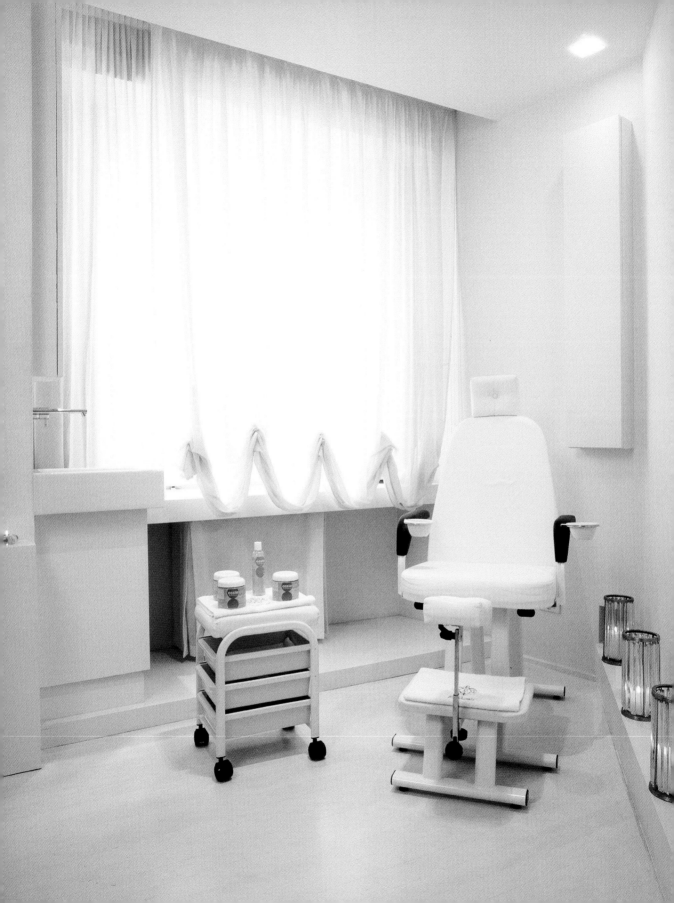

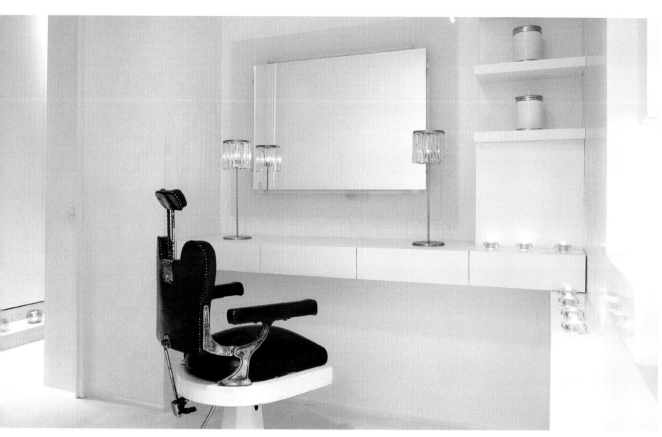

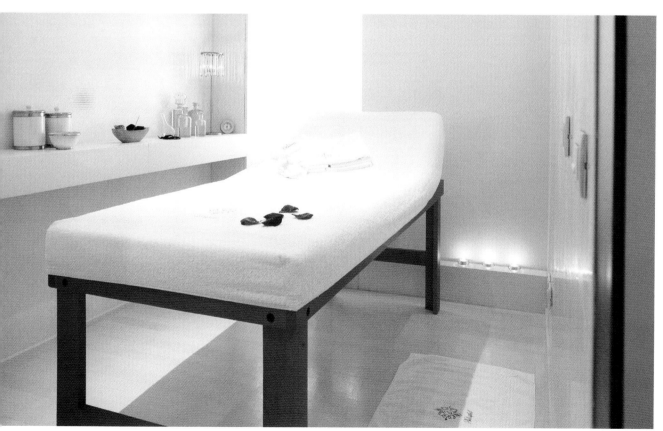

Banyan Tree Spa Shanghai, China

Architect: Architrave Design & Planning
Photography: Nacása & Partners
Level 3, The Westin Shanghai, Bund Center, 88 Henan Central Road, Shanghai 200002
Phone: +86 21 6335 1888
www.banyantree.com, spa-shanghai@banyantree.com
Services: Spa, 13 treatment rooms, five-element rooms, beauty salon, Banyan Tree gallery

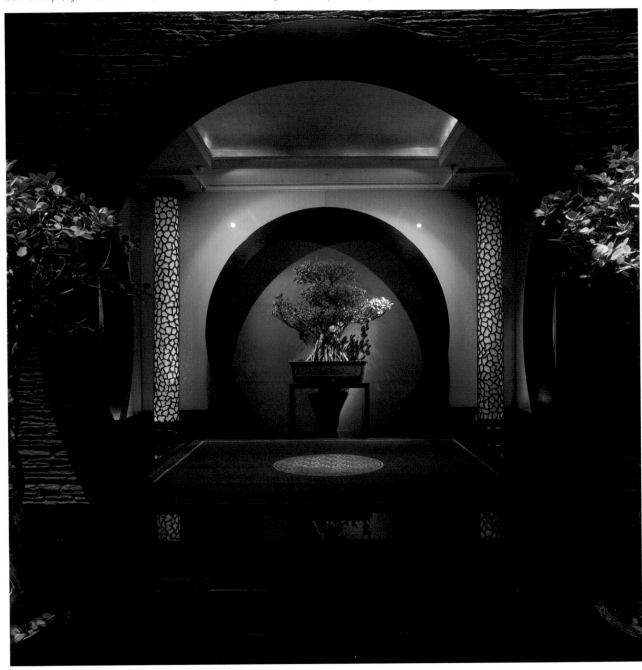

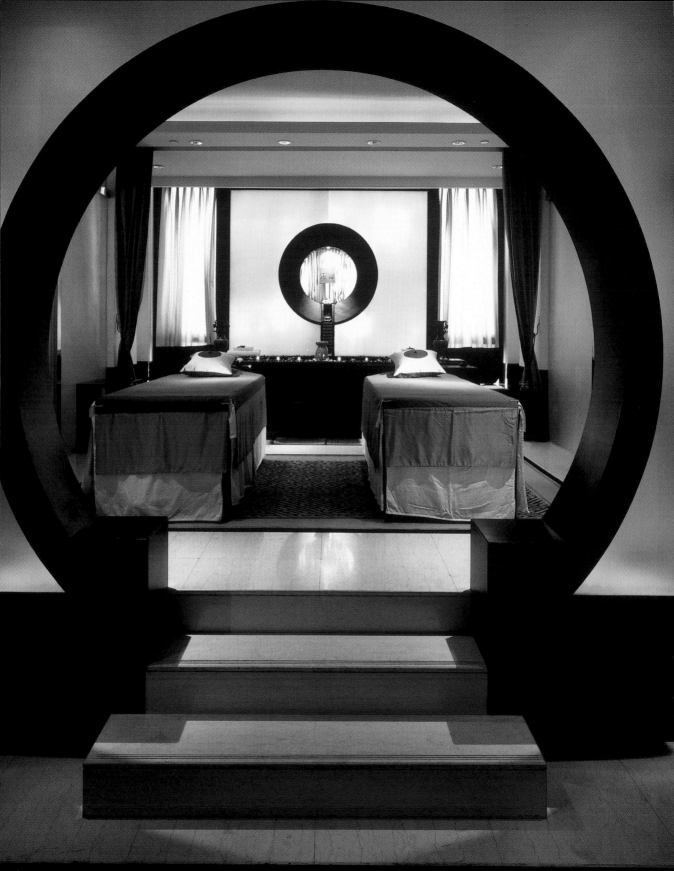

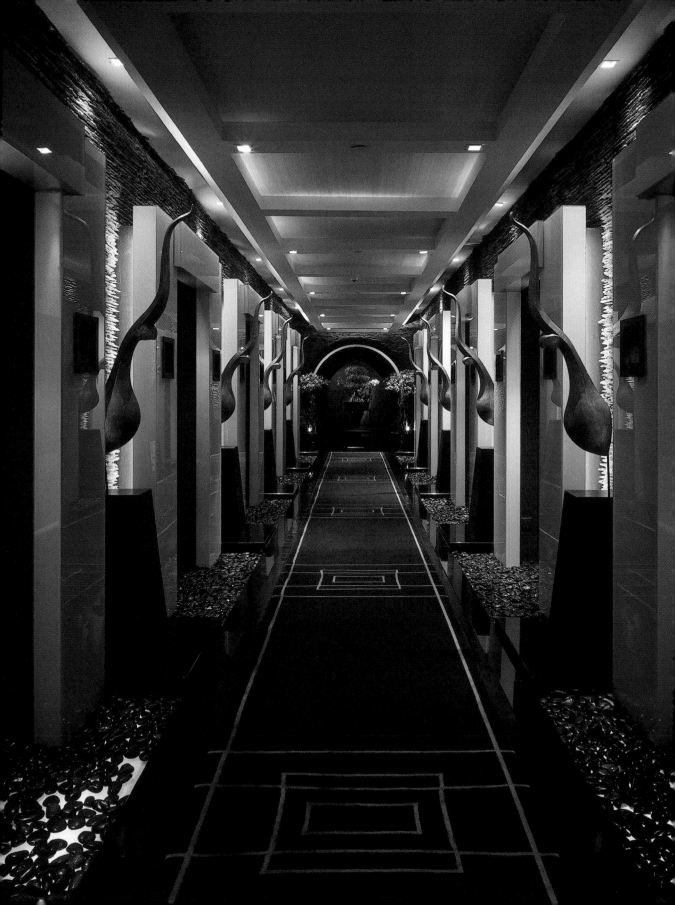

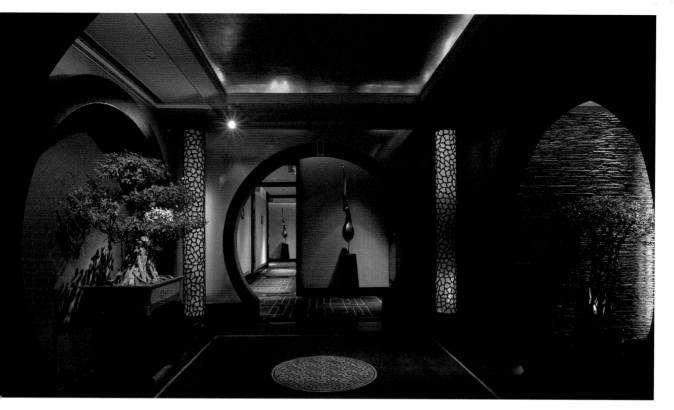

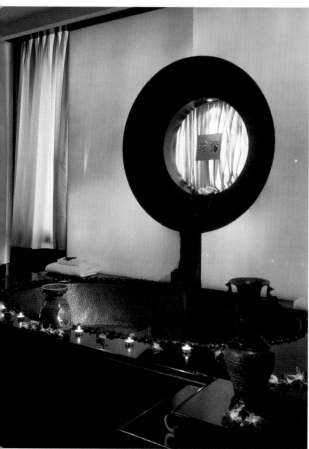

The third floor of a building on the popular Bund—the city's traditional waterfront promenade—is the setting for this luxurious wellness center, which aims to link Chinese design with the language of postmodernism. The center provides visitors with an array of opulent treatment rooms representing the five Chinese elements: earth, metal, water, wood and fire.

Im dritten Stockwerk des emblematischen Gebäudes Bund an der traditionellen Seepromenade der Stadt befindet sich dieses Luxusbad, in dem traditionelle, chinesische Elemente auf eine postmoderne Sprache treffen. Im Inneren des Bades taucht der Besucher in die Üppigkeit der Behandlungsräume ein, die die fünf chinesichen Elemente symbolisieren, Erde, Metall, Wasser, Holz and Feuer.

Au troisième étage du populaire Bund, sur la traditionelle promenade du bord de mer de la ville, se trouve cet établissement thermal de luxe dont le design cherche à associer tradition chinoise et langage post-moderne. Dans l'intérieur, le visiteur puet se submerger dans l'opulence des espaces de traitement représentés par les cinq éléments chinois : la terra, le metal, l'eau, le bois et le feu.

En la tercera planta de un edificio del popular Bund, el tradicional paseo marítimo de la ciudad, se encuentra este balneario de lujo que busca aunar en su diseño tradición china y lenguaje posmoderno. En su interior el visitante se sumerge en la opulencia de las habitaciones de tratamiento que representan los cinco elementos chinos: tierra, metal, agua, madera y fuego.

Al terzo piano di uno stabile del populare Bund, il famoso lungomare della città, si trova questo lussuoso centro di benessere il cui design cerca di mettere insieme tradizione cinese e linguaggio post-moderno. All'interno del complesso il visitatore si tuffa nell'opulenza della stanze riservate ai vari trattamenti che rapprasentano i cinque tradizionali elementi cinesi: terra, metallo, acqua, legno e fuoco.

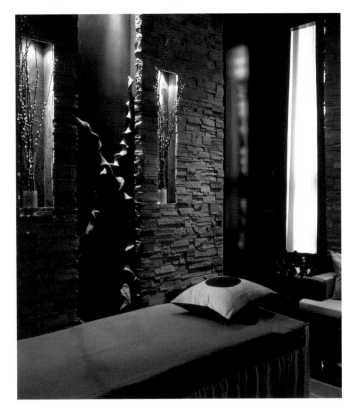

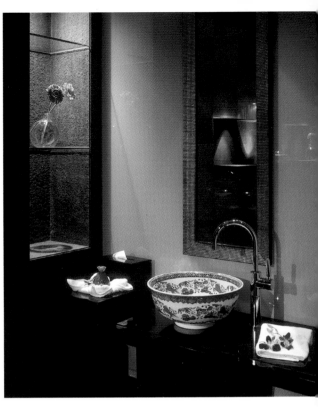

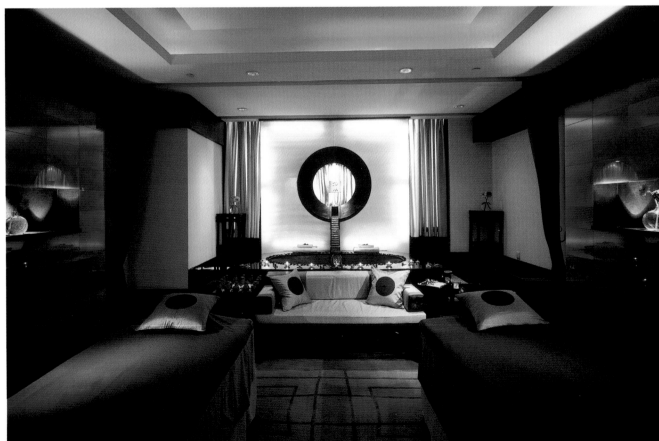

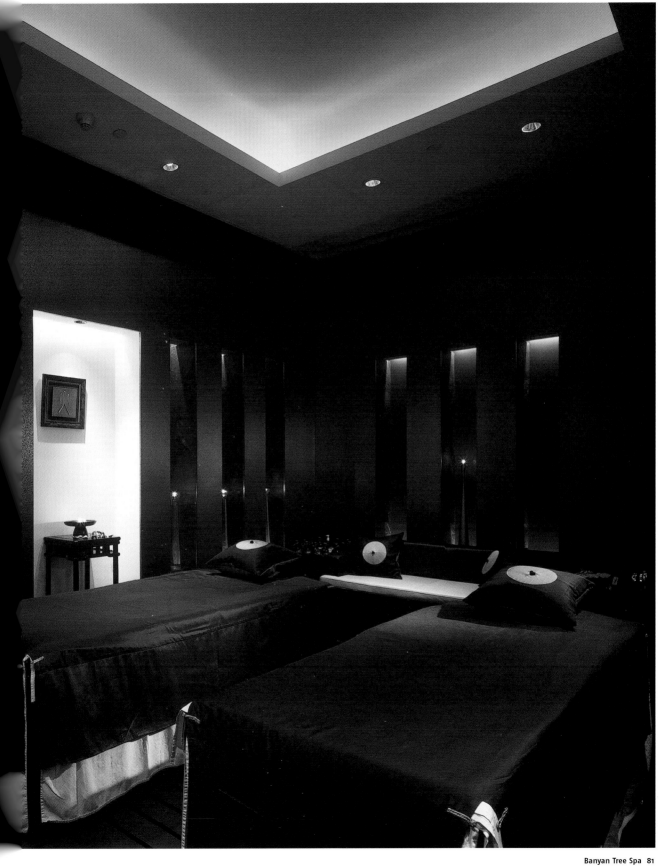

Holmes Place Am Gürzenich Cologne, Germany

Architect: ORMS Architects + Designers
Photography: Jürgen Schmidt
Köln-Stadthaus, Gürzenichstr. 6–16, 50667 Köln
Phone: +49 221 598 1414
www.holmesplace.com
Services: Pool, indoor cycling, yoga, ladies' gym, step aerobics, pilates, sauna, steam, solarium, spa, beauty clinic

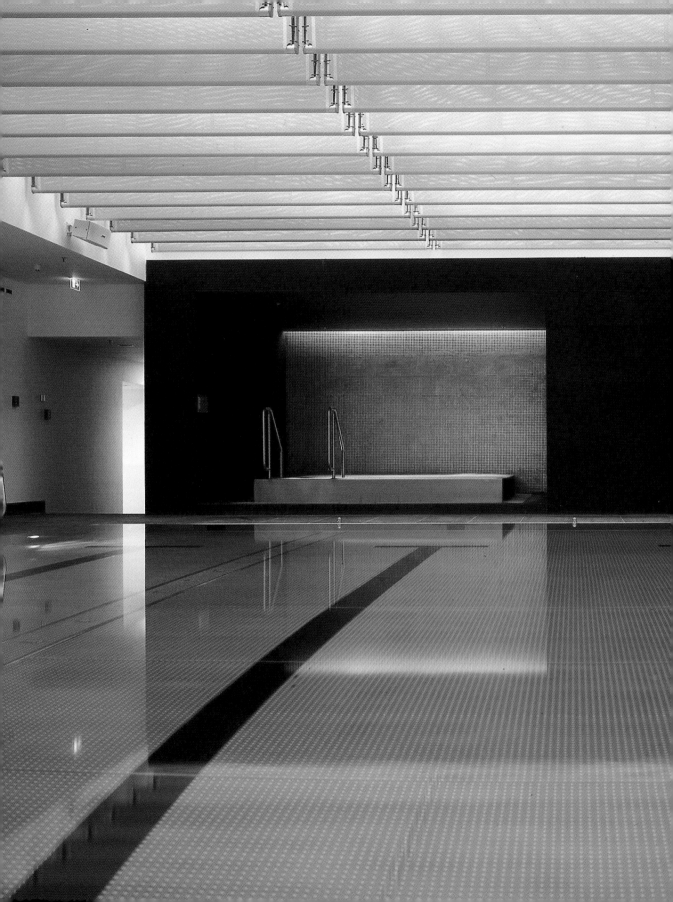

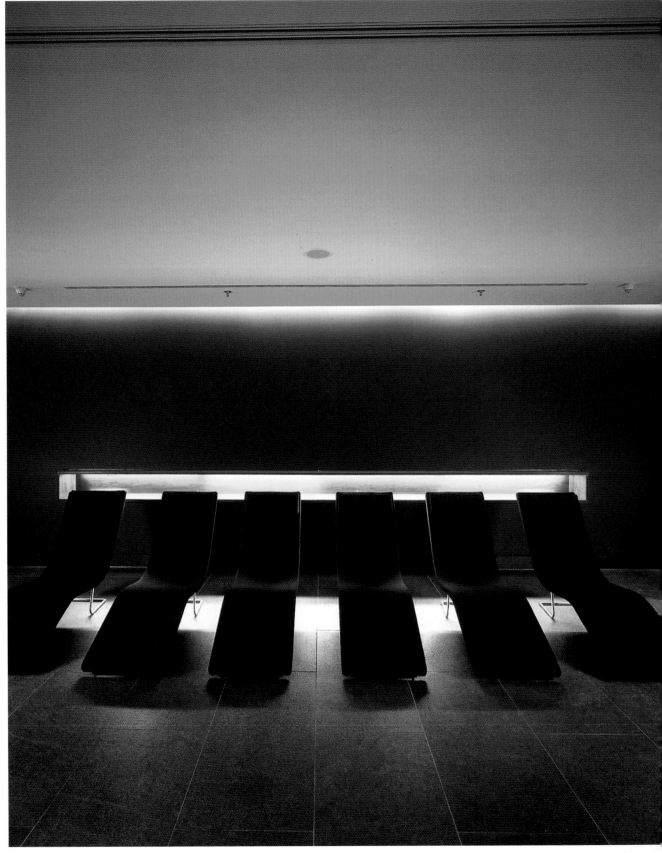

The mixture of contemporary architecture and almost Asian simplicity creates a very particular health club environment that allows an intensive workout as well as deep relaxation. Indirect lighting and a minimalist design confer this complex a sobriety not common to most beauty and fitness centers.

Die Mischung zeitgenössischer Architektur und asiatischer Schlichtheit schafft eine ganz spezielle Atmosphäre im Fitnesstudio, die sowohl ein intensives Training, als auch eine intensive Entspannung ermöglicht. Indirekte Beleuchtung und ein minimales Design verleihen diesem Komplex eine Nüchternheit, die für die meisten Schönheits- und Fitnesscenter unüblich ist.

Le mélange d'architecture contemporaine et de simplicité asiatique crée une ambiance particulière, propice à un entraînement intense ou à une relaxation totale. L'éclairage indirect et le design minimaliste confèrent à cet espace une sobriété que l'on rencontre rarement dans la plupart des centres de beauté et des gymnases.

La mezcla de arquitectura contemporánea y simpilicidad asiática crea un especial ambiente donde es posible entrenarse intensamente o entregarse a una profunda relajación. La iluminación indirecta y el diseño minimalista confieren a este centro una sobriedad difícil de encontrar en la mayor parte de los centros de belleza y de los gimnasios.

L'insieme di architettura contemporanea e semplicità asiatica creano un ambiente speciale dove ci si può allenare intensamente o dedicare a un profondo relax. L'illuminazione indiretta e il design minimalista apportano a questo centro di benessere una sobrietà che è difficile trovare nella maggior parte dei centri di bellezza e delle palestre.

Hotel RA Beach Thalasso-Spa Tarragona, Spain

Architect: Espinet/Ubach
Photography: Pep Escoda
Avinguda Sanatori 1, 43880 El Vendrell, Tarragona
Phone: +34 977 694 200
www.epoquehotels.com/tarragona.html
Services: Thalasso space, relaxing and therapeutic massages, shiatsu, ayurveda, chakra stone massage, magic honey, chocotherapy, pindasweda, peelings, fitness

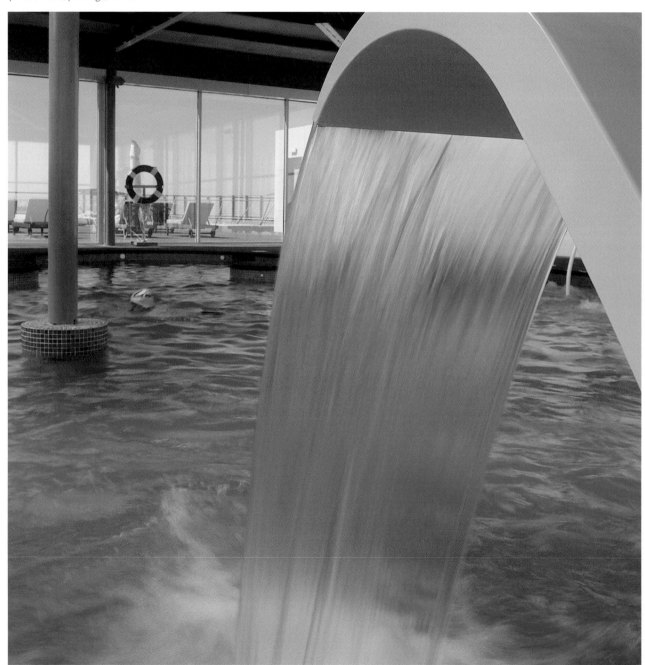

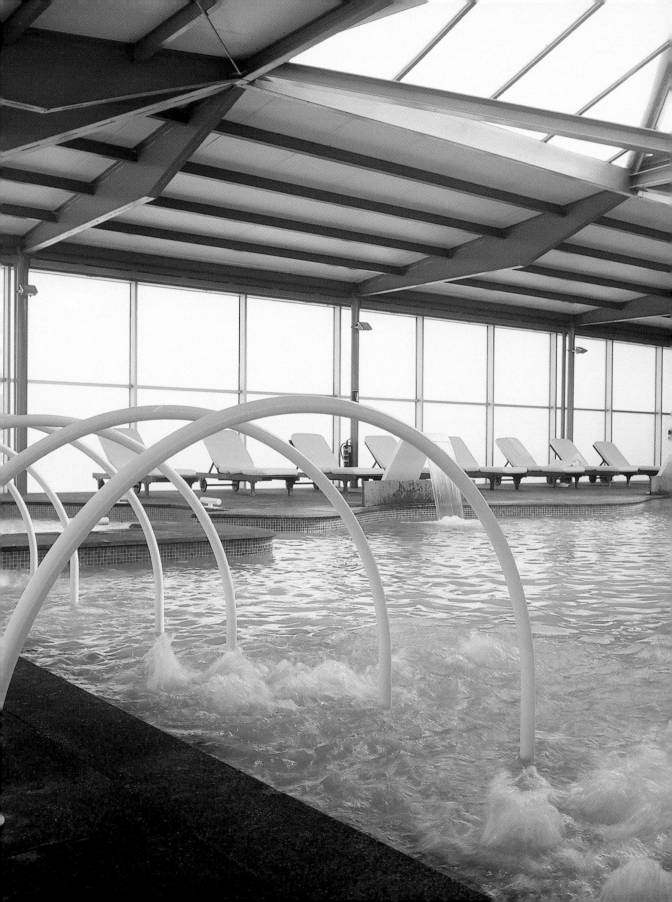

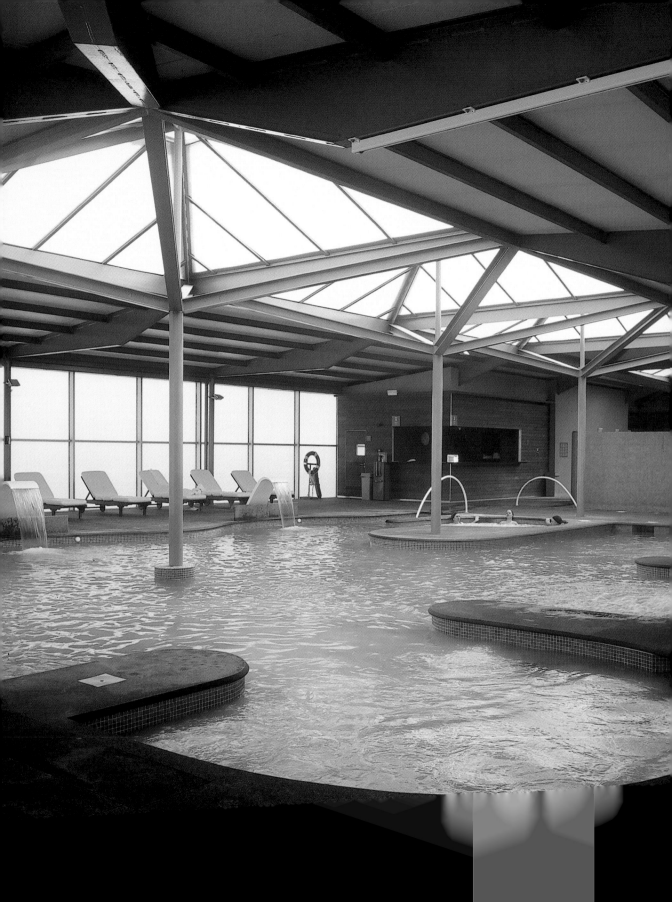

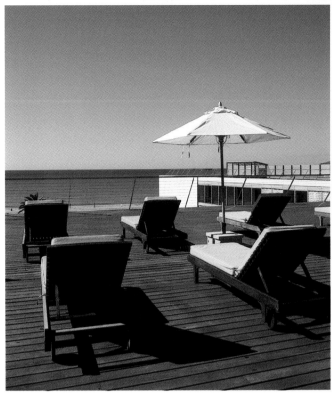

This luxurious thalassotherapy center is housed in a former children's hospital overlooking the sea. Water here becomes an additional decorative and architectural element that helps to delimit spaces.

Dieses luxuriöse Zentrum für Thalassotherapie befindet sich einem ehemaligen Kinderhospital direkt am Meer. Das Wasser wurde zu einem weiteren dekorativen und architektonischen Element, das die Räume begrenzt.

Ce luxueux centre de thalassothérapie se situe dans un ancien sanatorium pour enfants, face à la mer. L'eau devient un élément décoratif et architectural supplémentaire et sert à délimiter l'espace.

Este lujoso centro de talasoterapia se encuentra en un antiguo sanatorio infantil, frente al mar. El agua se convierte en un elemento decorativo y arquitectónico más y ayuda a delimitar los espacios.

Questo elegante centro di talassoterapia si trova nei locali di un'antica clinica pediatrica, di fronte al mare. L'acqua diventa un ulteriore elemento architettonico e decorativo che serve a delimitare i vari ambienti.

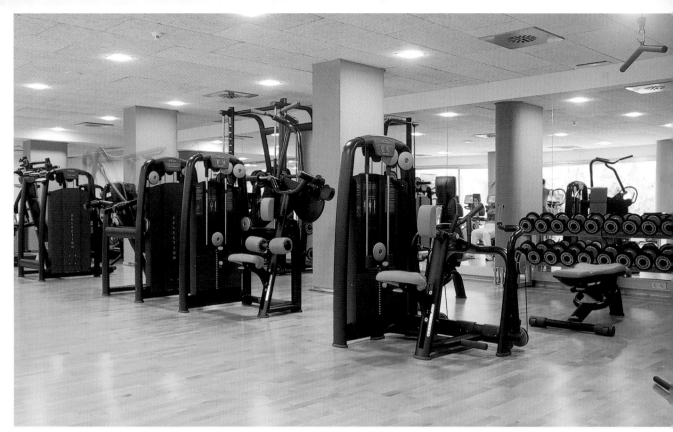

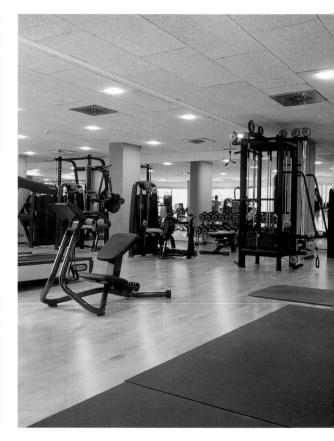

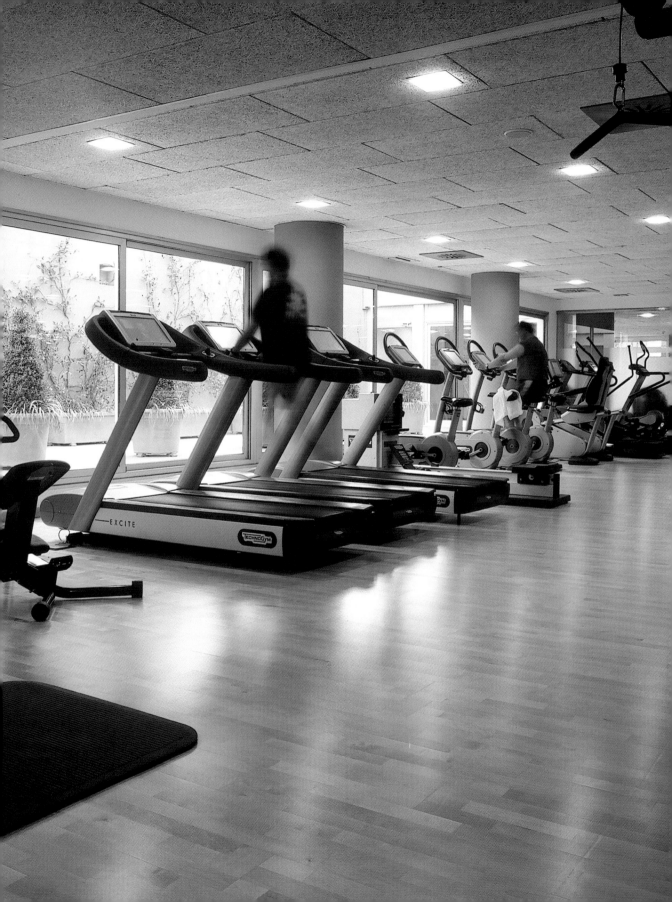

Bad Elster Spa Bad Elster, Germany

Architect: Behnisch & Partner
Photography: Josep Maria Molinos
Bad Strasse 6, 08645 Bad Elster
Phone: +49 3743 771 111
www.saechsische-staatsbaeder.de, info@saechsische-staatsbaeder.de
Services: No-smoking rooms, minibar, restaurants, some serving dietary foods, sauna, solarium, sports equipment

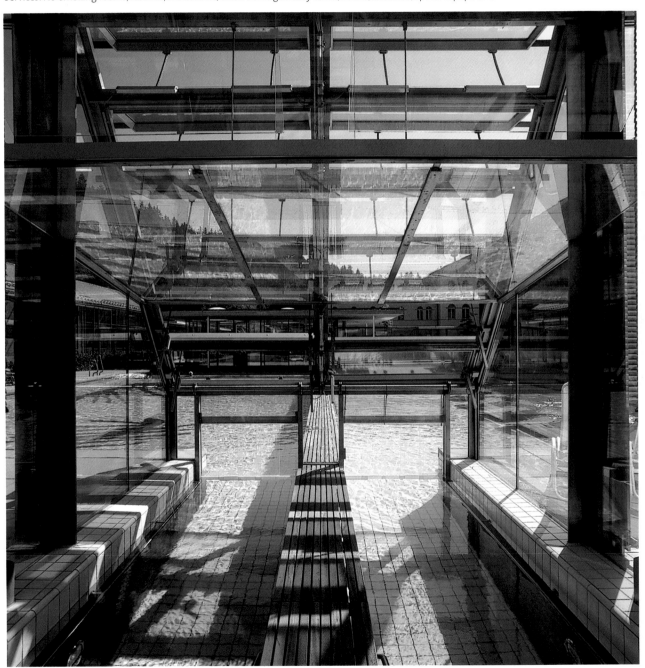

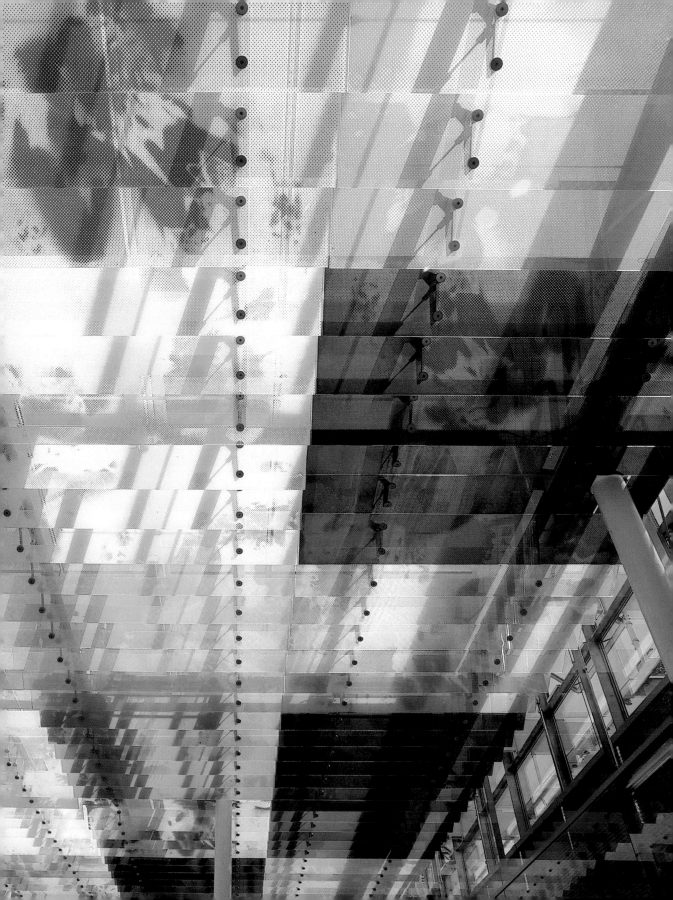

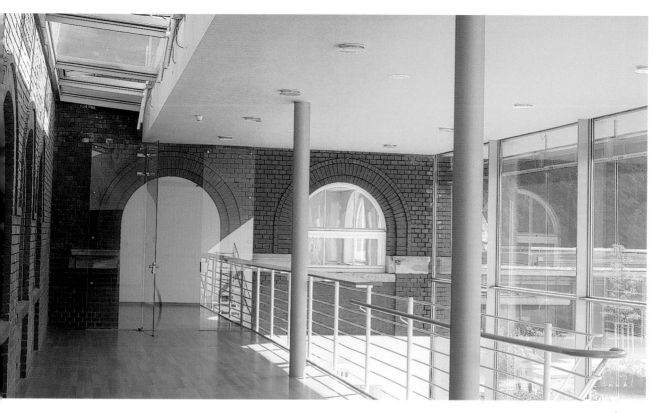

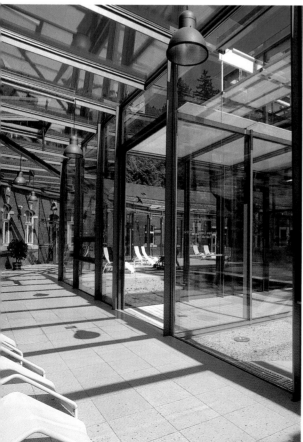

The primary objective of the architects consisted in restoring the value of the complex by redesigning the central zone and harmonizing the new structures with the existing ones. The roof structure features colored glass slats which can be adjusted to provide protection from the sun and brightness.

Das Hauptziel der Architekten bestand darin, den Komplex aufzuwerten, indem sie die zentrale Zone neu entwarfen und die neuen Strukturen den bestehenden anpassten. Die Dachkonstruktion ist mit farbigen Glasplatten ausgestattet, die bei Bedarf verstellt werden können, um so Schutz vor der reflektierenden Sonne zu bieten.

L'objectif principal des architectes a été de revaloriser le complexe, après avoir redessiner la zone centrale et tenter d'harmoniser les nouvelles constructions à celles qui existaient déjà. Le système de construction de la couverture comprend des lames de verre teinté qui protègent du sol et évitent les reflets.

El principal objetivo de los arquitectos consistió en revalorizar el complejo; algo que consiguieron tras rediseñar la zona central e intentar armonizar las nuevas construcciones con las ya existentes. El sistema constructivo de la cubierta incluye unas lamas de cristal coloreado que protegen del sol y evitan los reflejos.

Il principale obiettivo degli architetti è stato quello di rivalorizzare il complesso; una cosa che ottennero ridisegnando la zona centrale e armonizzando la nuova costruzione con quelle preesistenti. Il sistema costruttivo della copertura è composto da lamine di vetro colorato che proteggono dal sole ed evitano i riflessi.

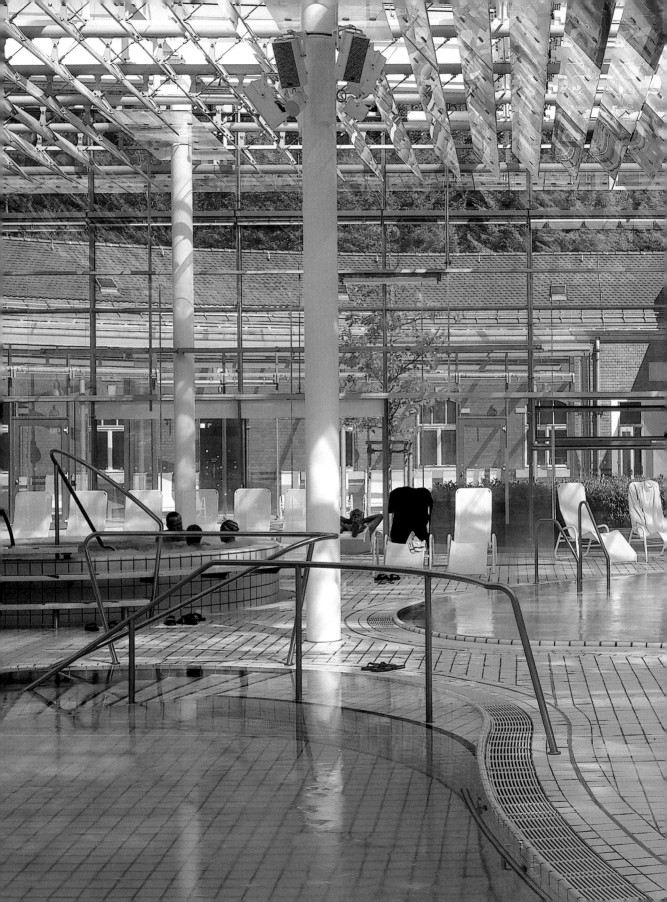

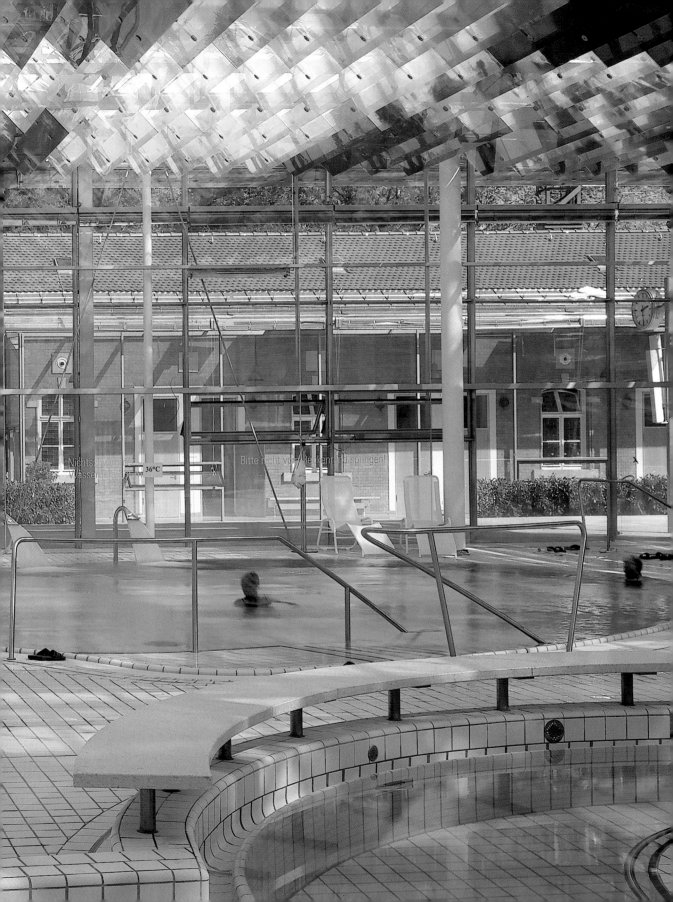

Roppongi Hills Spa Tokyo, Japan

Architect: Conran and Partners
Photography: Conran and Partners
6-12-3, Roppongi, Minato-ku, Tokyo 106-0032
www.hillsspa.com
Phone: + 66 3 6406 6550
Services: Gym, pool, aquabics, jacuzzis, saunas, head spa treatments, aesthetic room, restaurant, deck

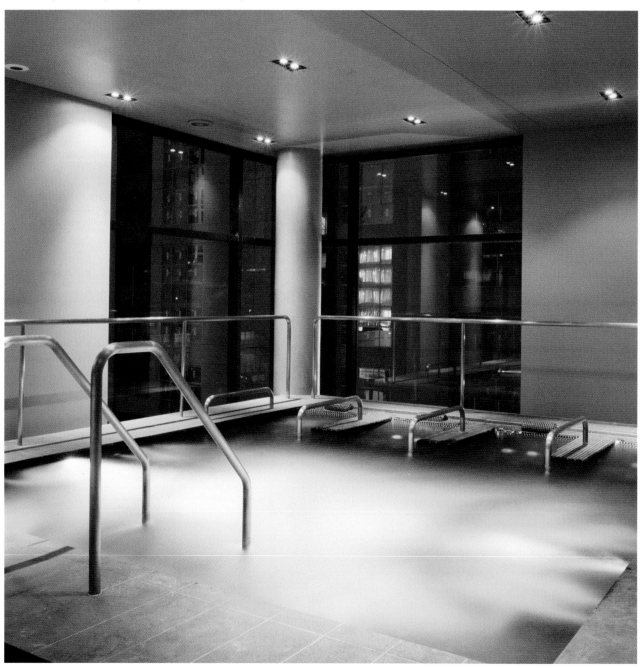

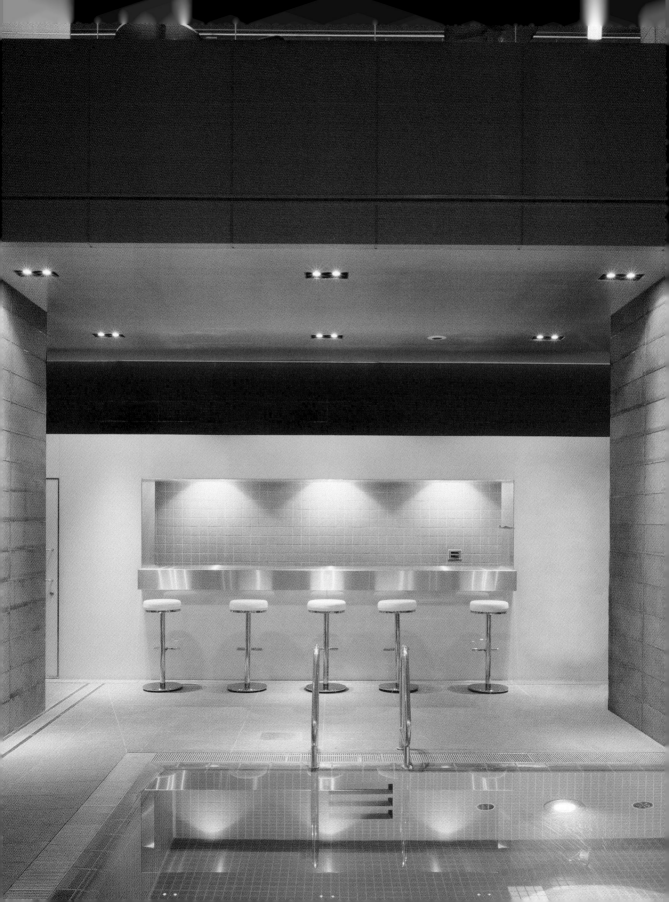

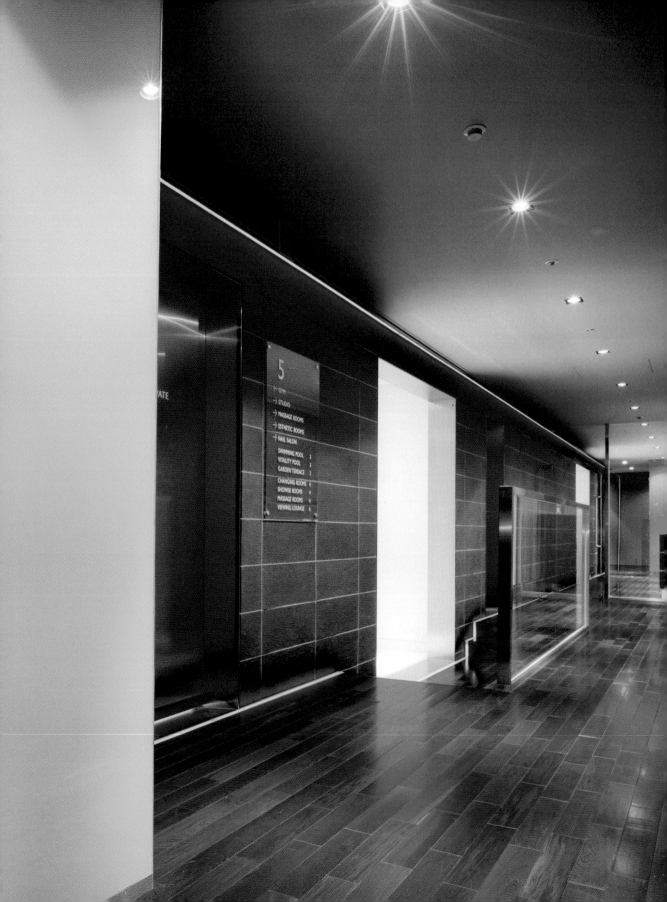

5

→ GYM

→ STUDIO

→ MASSAGE ROOMS

→ ESTHETIC ROOMS

→ NAIL SALON

SWIMMING POOL

VITALITY POOL

GARDEN TERRACE

CHANGING ROOMS

SHOWER ROOMS

MASSAGE ROOMS

VIEWING LOUNGE

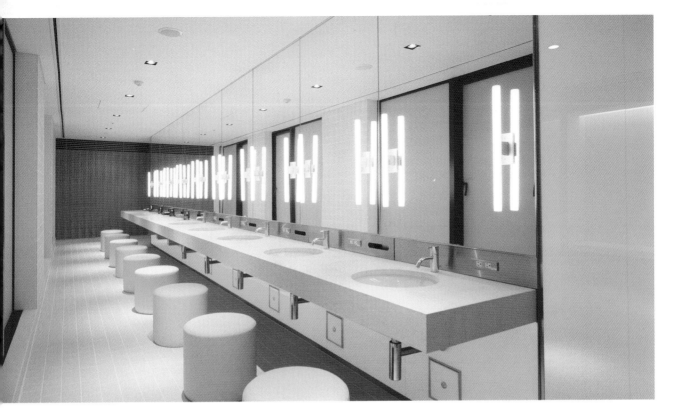

The design uses minimal elements and creates a paradise amidst the bustle and pollution of the city. This 'urban retreat' consists of two distinct areas: one for preparation and the other for restoration.

Die Raumgestaltung ist durch den minimalen Einsatz gestalterischer Elemente geprägt. Es entstand ein Paradies inmitten des Lärms und des Schmutzes der Stadt. Diese Stadtoase besteht aus zwei verschiedenen Bereichen für Behandlungen und Entspannung.

Le design décline les éléments minimalistes et crée un paradis au cœur de l'agitation et de la pollution urbaine. Ce « refuge urbain » comporte deux zones distinctes : une pour la mise en forme et l'autre consacrée à la restauration.

El diseño emplea los elementos mínimos y crea un paraíso en medio del bullicio y la contaminación de la ciudad. Este "refugio urbano" se compone de dos áreas distintas: una de preparación y otra de restauración.

Il design di questo centro termale si avvale di elementi minimalisti grazie ai quali crea un angolo di paradiso in mezzo al frastuono e l'inquinamento della città. Questo "rifugio urbano" è composto da due diverse aree: una per la preparazione fisica e l'altra di ristoro.

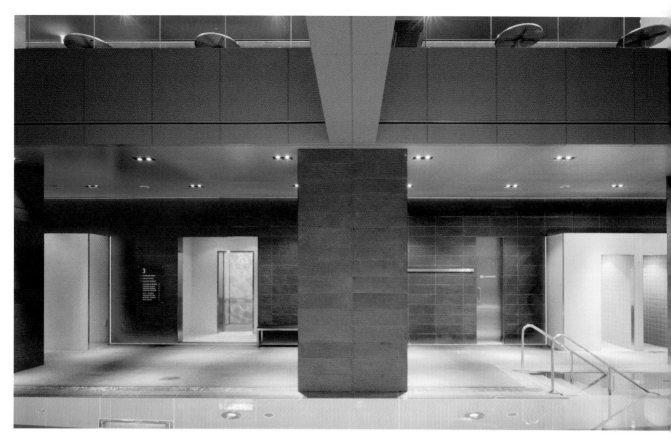

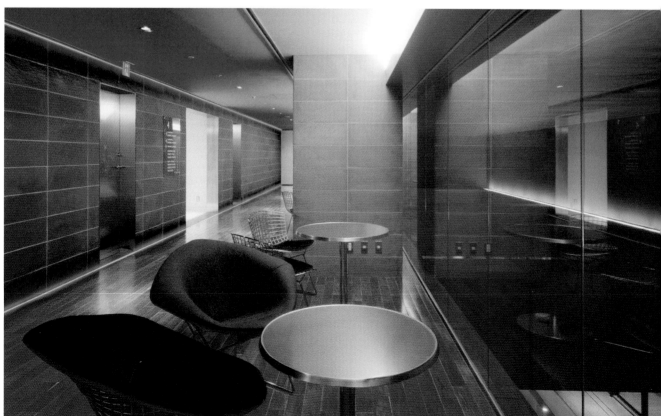

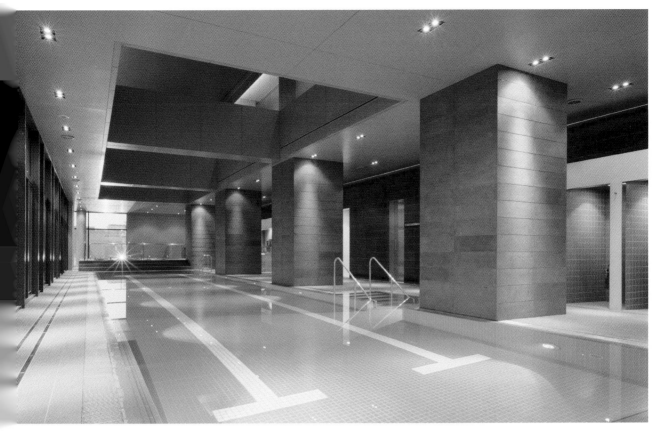

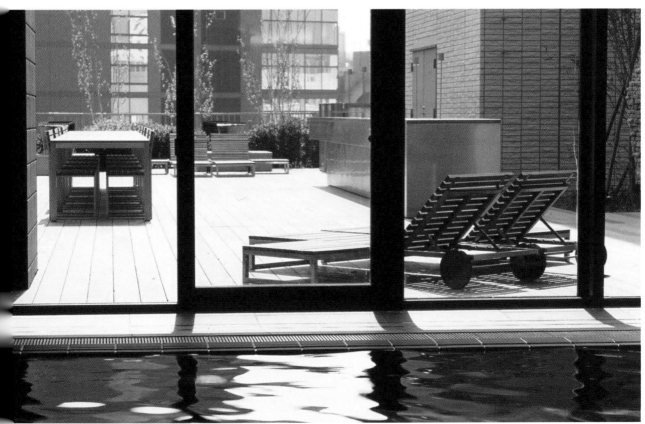

O2 Centro Wellness Barcelona, Spain

Architect: Alonso Balaguer and Arquitectos Asociados
Photography: Josep Maria Molinos
Eduardo Conde 2–6, 08064 Barcelona
Phone: +34 93 205 3976
www.wellness-experts.com/pedralbes
Services: Aquatic area, spa, fitness center, beauty center, solarium, medical area (International Center for Advanced Medicine), children's play zone

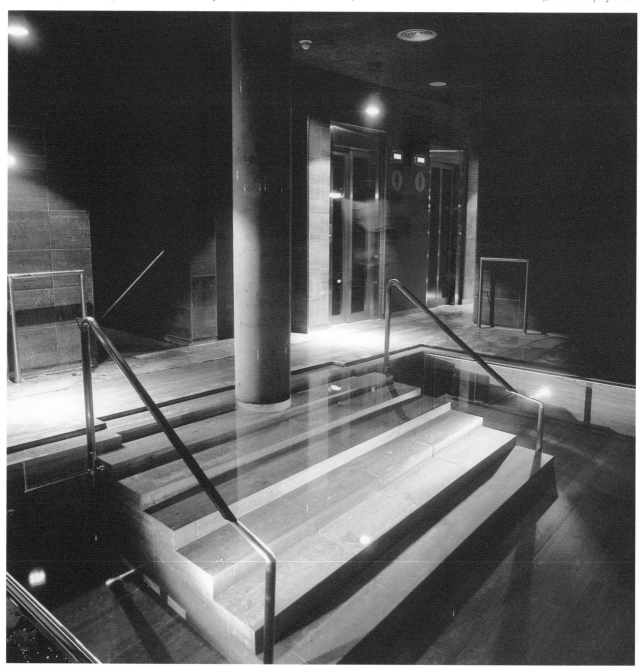

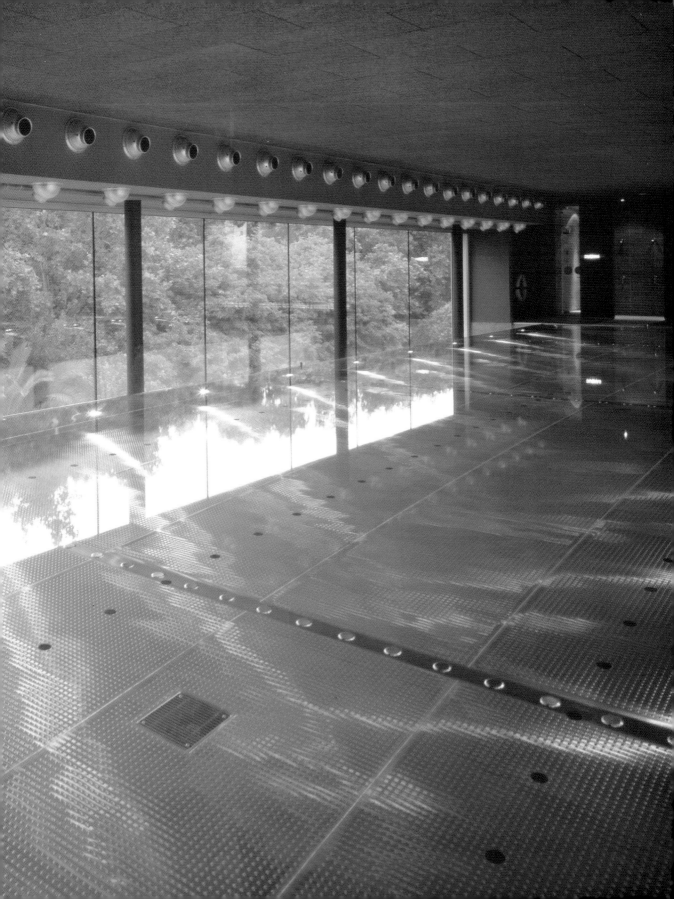

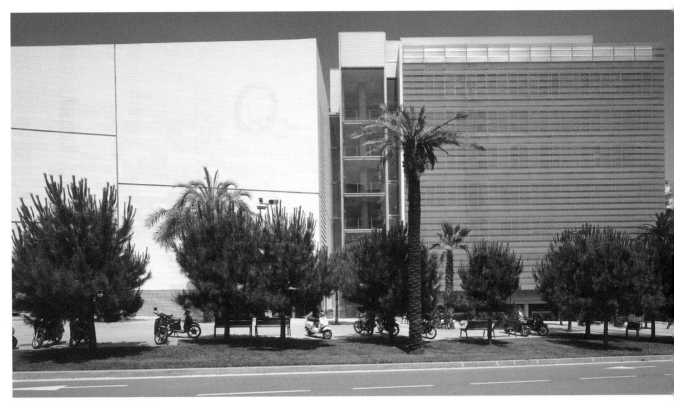

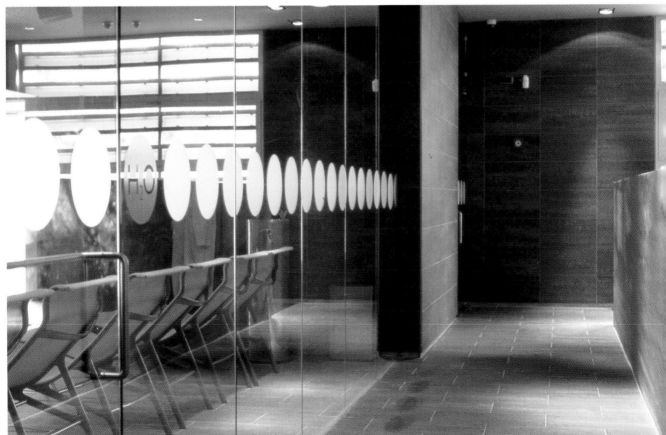

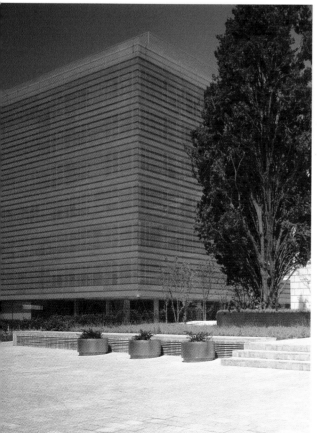

The expansive glass surfaces of the building façades and interior walls allow panoramic views of the neighborhood and visually link the different areas of the club. In addition, the sports complex also serves as a meeting point for local residents, performing an important social function within the community.

Die ausgedehnten Glasflächen der Fassade und der Innenwände ermöglichen einen Panoramablick auf die Umgebung und verbinden so die unterschiedlichen Bereiche des Klubs. Zusätzlich dient der Sportkomplex auch als Treffpunkt für die Anwohner und erfüllt damit eine wichtige soziale Funktion für die Gemeinde.

Les grandes parois de verre qui enveloppent les façades de l'édifice ou qui divisent les espaces intérieurs, permettent de jouir du panorama environnant ou d'unir visuellement les différents espaces de vie du club. Le complexe sportif se métamorphose aussi en un lieu de rencontre pour les voisins du quartier, revêtant ainsi une fonction sociale primordiale.

Las grandes superficies de cristal que envuelven las fachadas del edificio o dividen los espacios interiores permiten disfrutar de las panorámicas del vecindario y relacionar visualmente las diferentes estancias del club. El complejo deportivo, además, se convierte en un lugar de encuentro para los vecinos del barrio, cumpliendo una función social de gran importancia.

Le grandi superfici di vetro che avvolgono l'edificio e ne formano le pareti permettono di godere di viste panoramiche al quartiere e collegano visualmente le diver se zone del club. Il complesso sportivo è, inoltre, un punto di riunione per gli abitanti del quartiere e svolge una importante funzione sociale per la comunità.

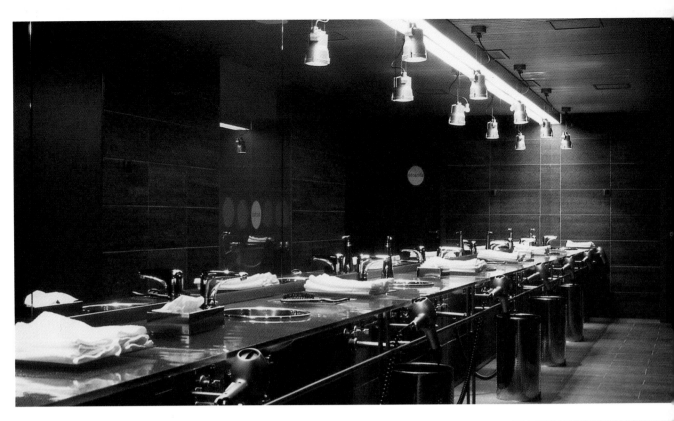

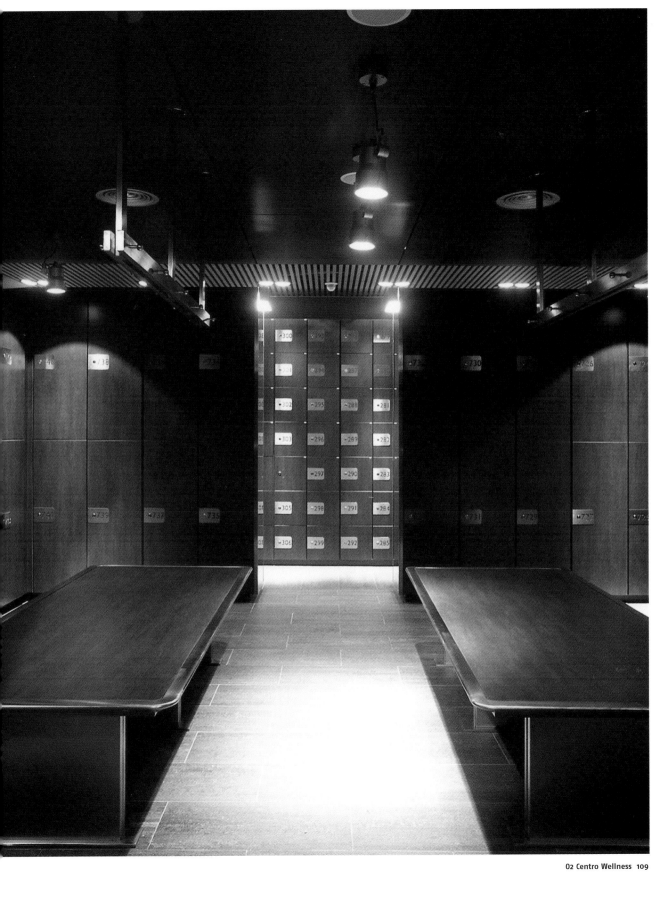

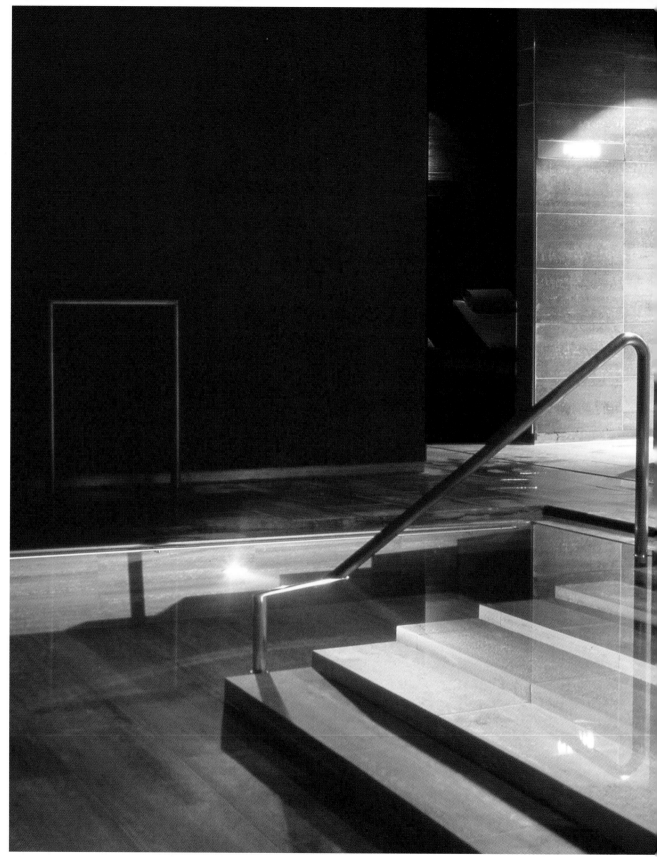

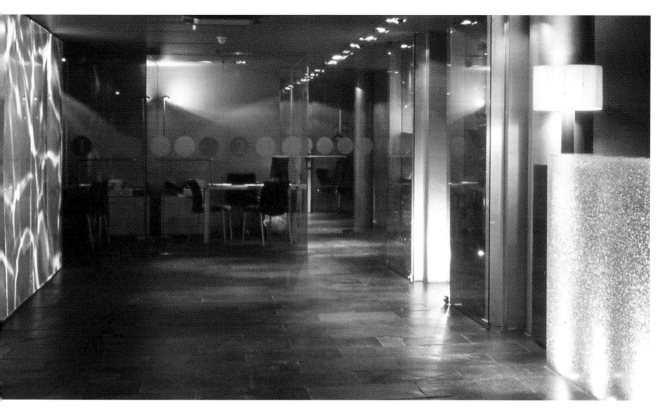

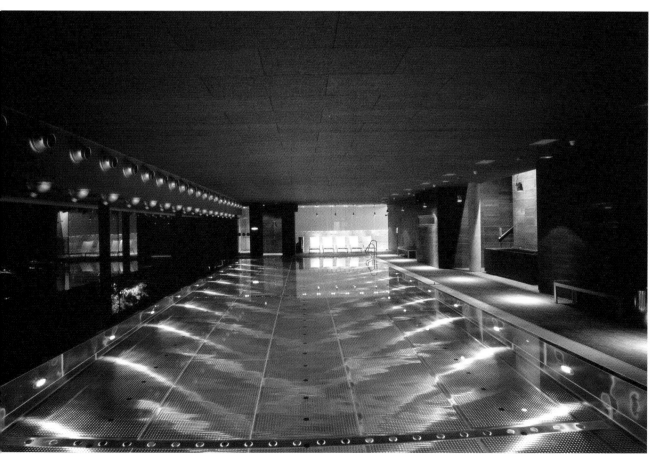

Plateau Hong Kong, China

Architect: Monford & Company
Photographer: Vera Mercer
Plateau, Grand Hyatt Hong Kong, 1 Harbour Road, Hong Kong
Phone: +86 852 2584 7688
www.plateau.com.hk, plateau@grandhyatt.com.hk
Services: Fitness, spa, massage, footcare, pedicure, handcare, manicure, vichy shower treatments

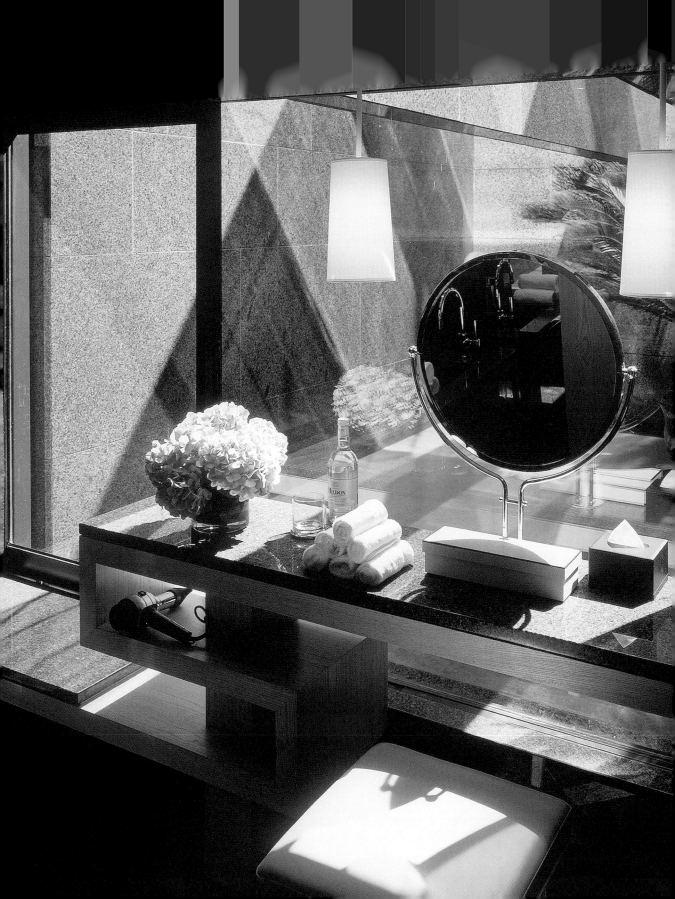

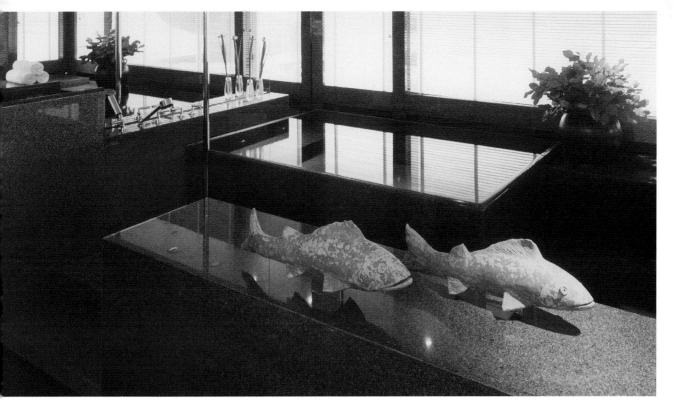

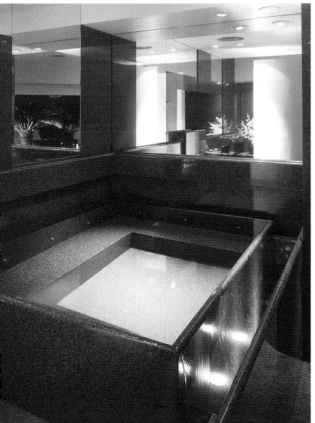

The exclusive design follows the lines characteristic of the Grand Hyatt chain of luxury hotels, in which dark colors and natural materials predominate.

Das exklusive Design entspricht der typischen Linie der luxuriösen Hotelkette Grand Hyatt. Es herrschen dunkle Farben und Naturmaterialien vor.

Son design exclusif suit la ligne caractéristique de la chaîne somptueuse des hôtels Grand Hyatt, défini par la prédominance de tons obscurs et de matériaux naturel.

Su exclusivo diseño sigue la línea característica de la lujosa cadena de hoteles Grand Hyatt; predominan en él los colores oscuros y los materiales naturales.

Il suo design esclusivo segue la linea caratteristica della lussuosa catena alberghiera Grand Hyatt; vi predominano i colori scuri e i materiali naturali.

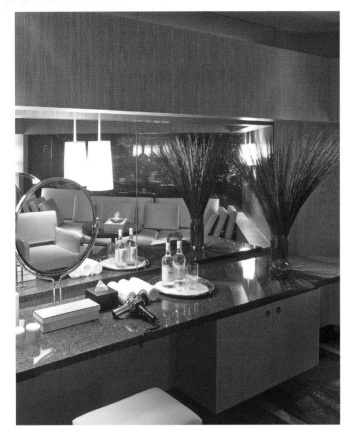
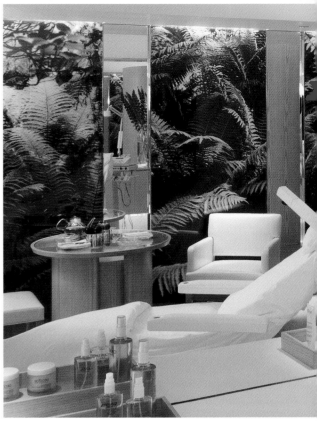
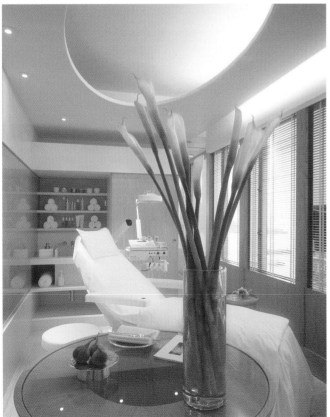
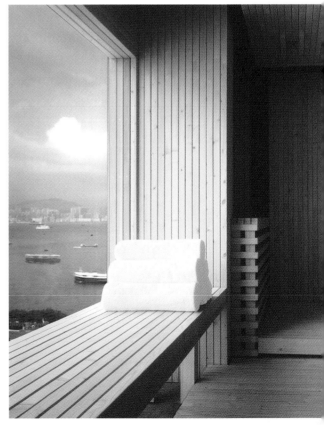

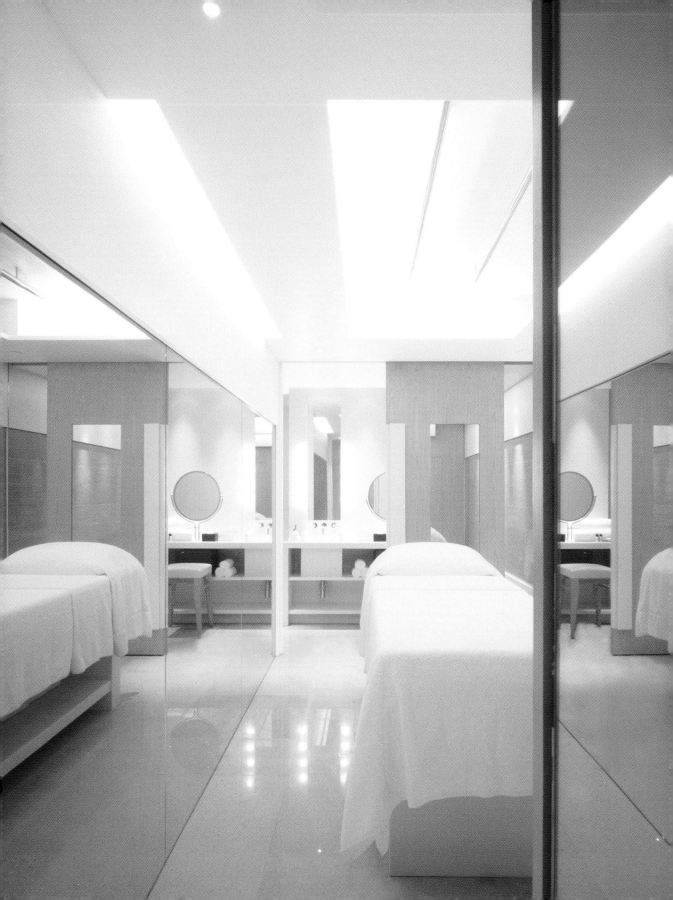

Victoria-Jungfrau Grand Hotel & Spa Interlaken, Switzerland

Architect: Behles + Partner

Photography: Victoria-Jungfrau Grand Hotel & Spa

Höheweg 41, 3800 Interlaken

Phone: +41 33 828 28 28

www.victoria-jungfrau.ch, interlaken@victoria-jungfrau.ch

Services: Fitness, wellness, spa cuisine, steam bath, finnish sauna, relaxation, hot stone therapy, private spa for two people, pool, whirlpool, salt water jacuzzi, solarium, bio-sauna with active light therapy

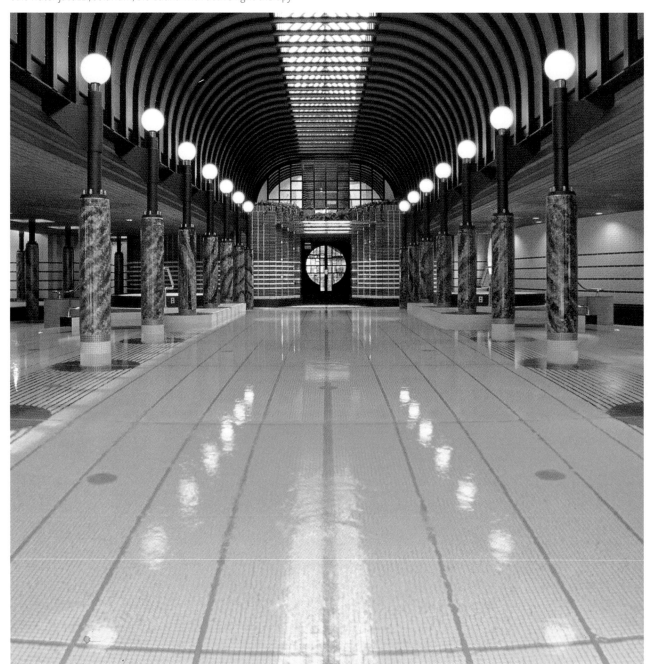

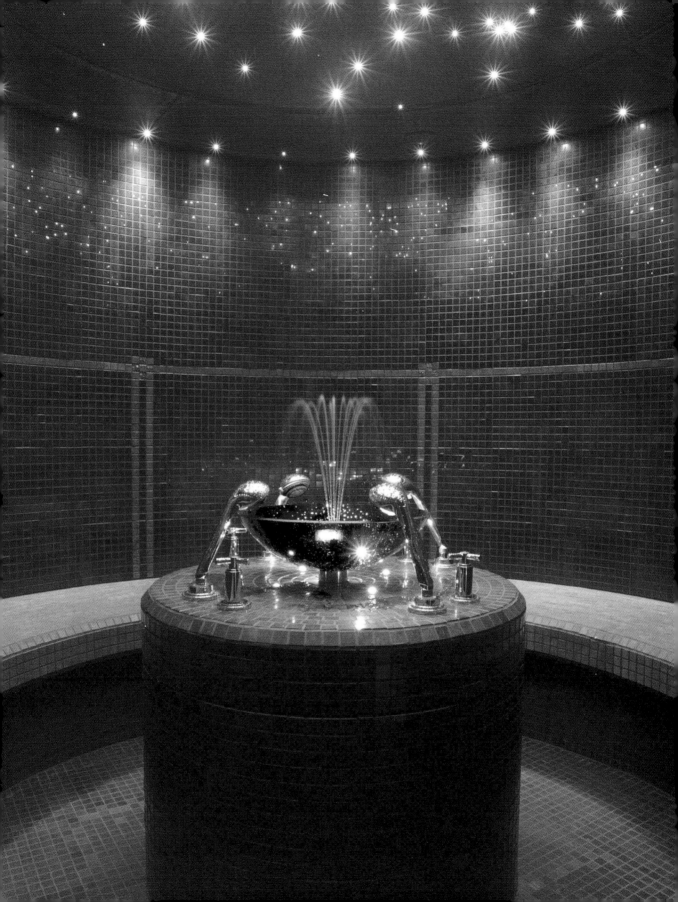

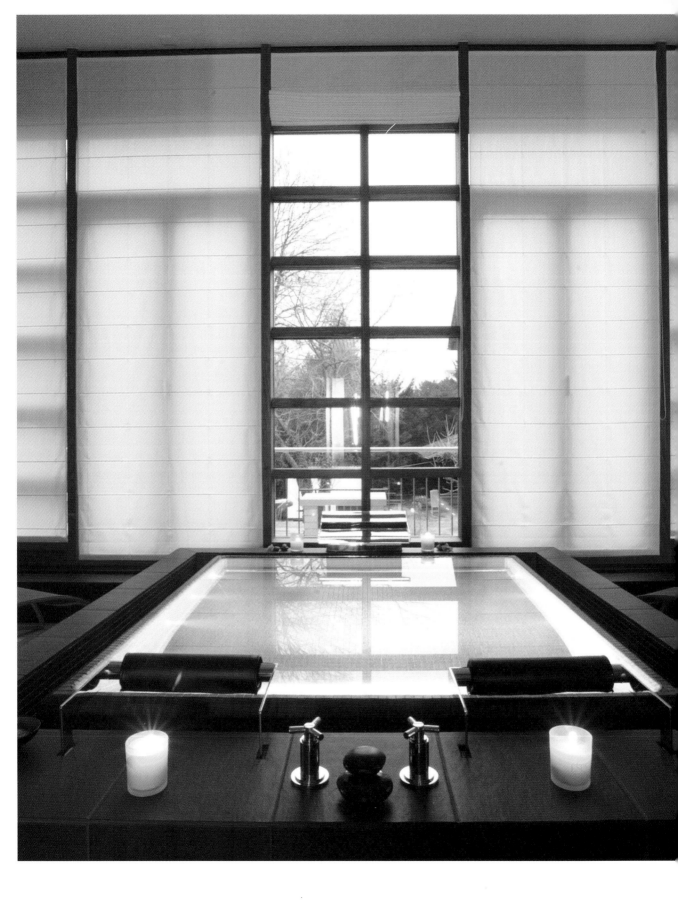

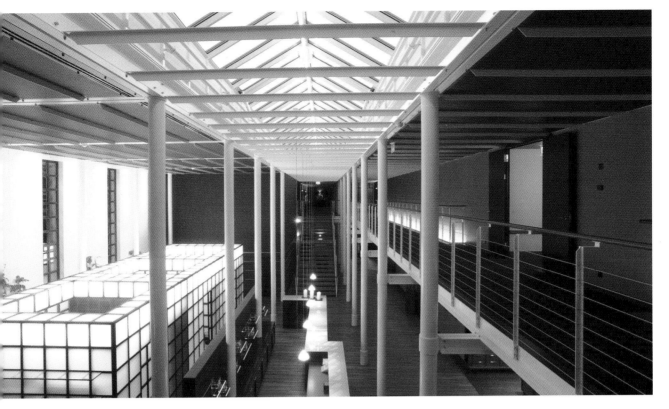

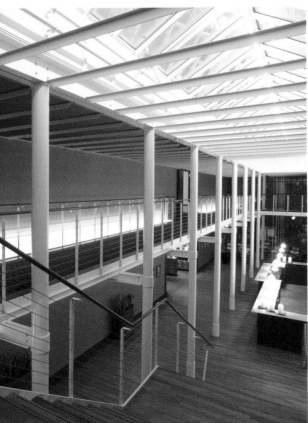

One of the challenges involved in refurbishing the building was to harmonize the new extension with the old construction. The challenge was met thanks to the use of high-quality materials and adequate lighting.

Es stellte eine Herausforderung an die Planer bei der Umgestaltung des Gebäudes dar, den neuen Anbau in das alte Gebäude zu integrieren und gleichzeitig den Ansprüchen des modernen Lebens gerecht zu werden. Dies gelang durch die Verwendung hochwertiger Materialien und einer geeigneten Beleuchtung.

Un des défis posés par la restructuration de l'édifice, a été d'intégrer le nouvel agrandissement à l'ancienne construction. La solution a été d'employer des matériaux de première qualité et un éclairage adéquat.

La remodelación del edificio se proponía integrar la nueva extensión en la construcción antigua; lo que se consiguió gracias al empleo de materiales de gran calidad y a una iluminación adecuada.

La ristrutturazione dell'edificio presentava varie difficoltà, come l'integrazione dei nuovi locali nella costruzione antica, che fu risolta con l'uso di materiali di ottima qualità e un'adeguata illuminazione.

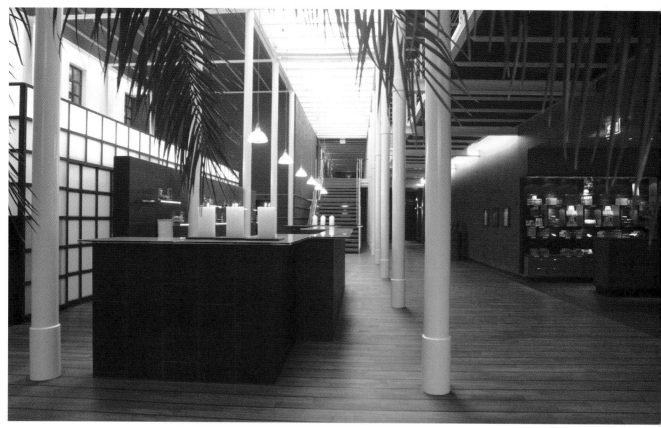

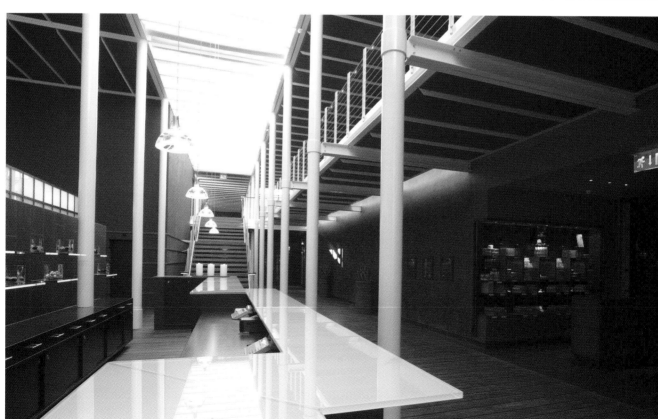

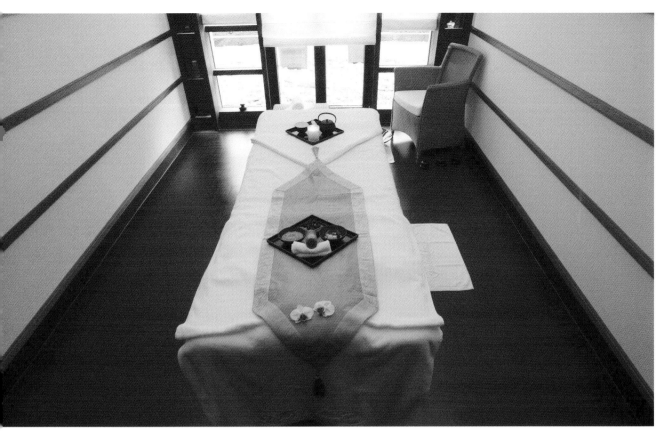

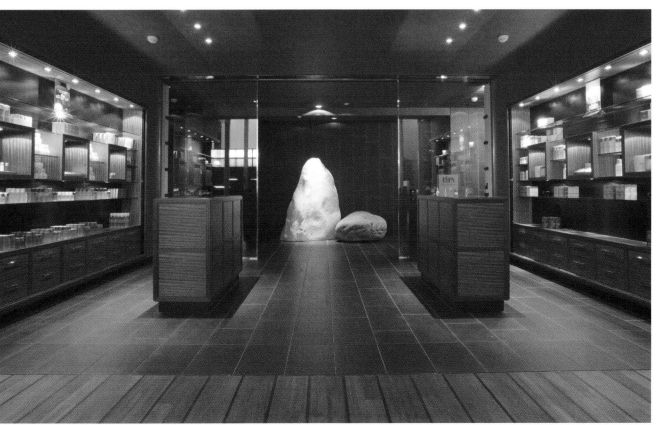

Holmes Place Hamburg Hamburg, Germany

Architect: SEHW Architekten
Photography: Jürgen Schmidt
www.holmesplace.com
Außenalster, Bostelreihe 2, 22083 Hamburg
Phone: +49 40 280 026 26
Services: Fitness, ladie's gym, aqua gym, yoga, tai-chi, pilates, body pump, indoor cycling, kick fit, ozone treated swimming-pool, sauna, steam bath, solarium, jacuzzi, massages, club lounge

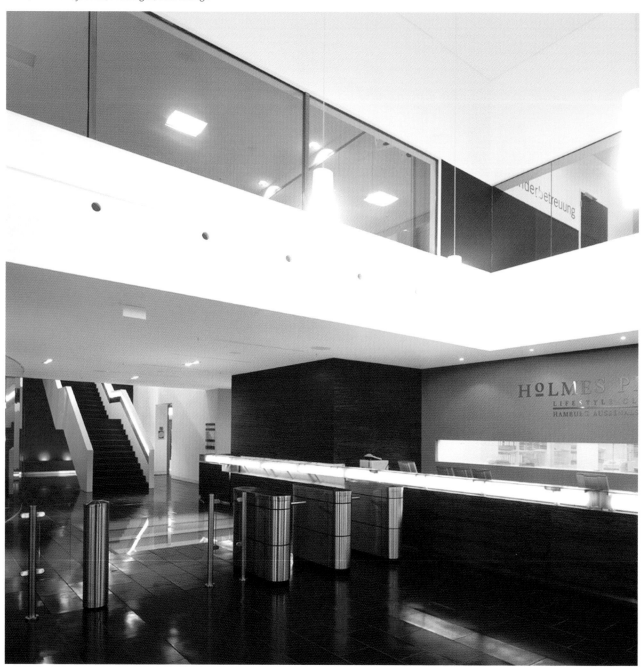

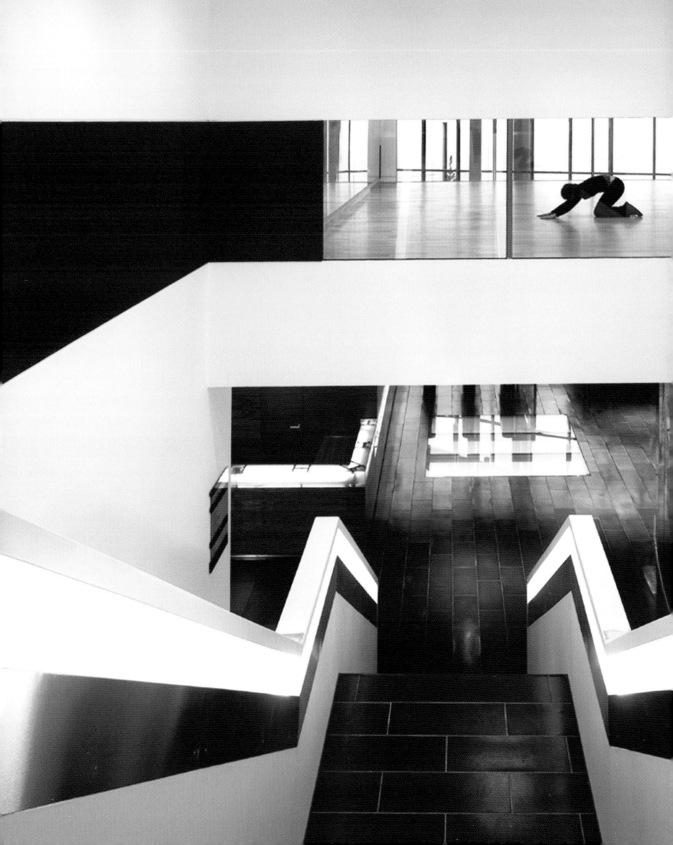

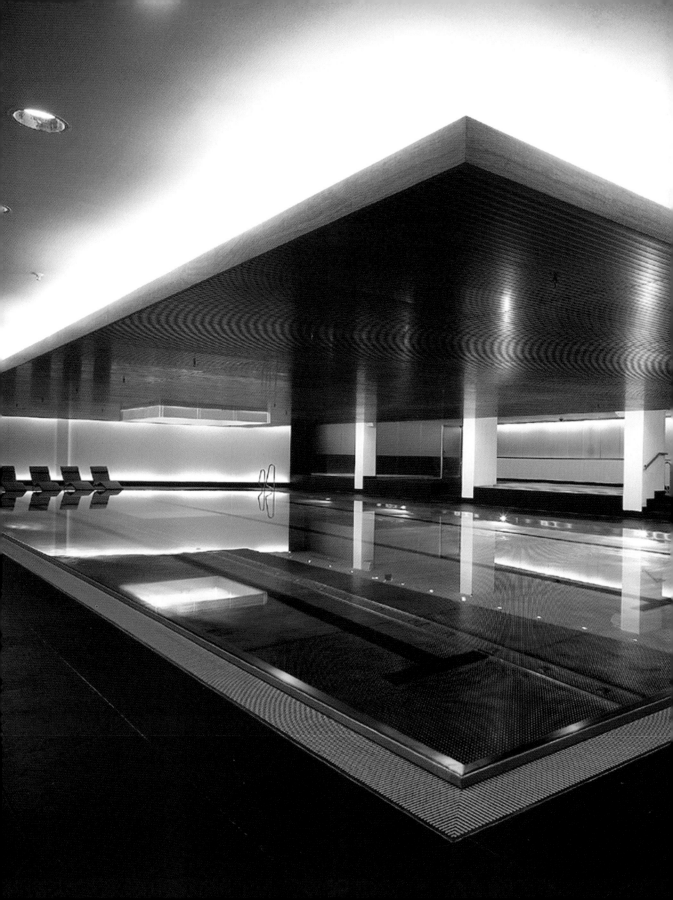

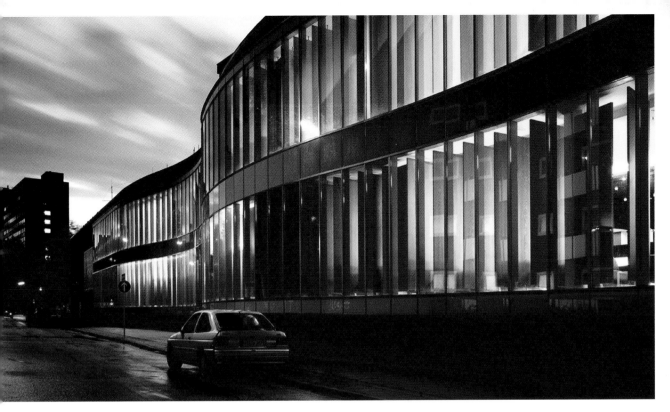

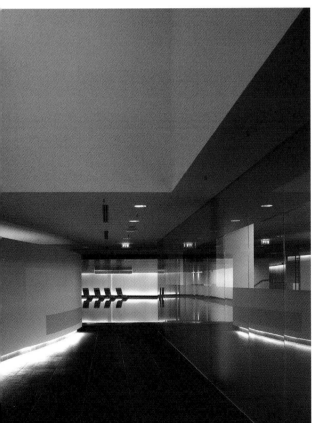

This center offers a combination of wellness, fitness and beauty treatment, its design combining modern architecture and Asian simplicity to create a warm, relaxed atmosphere.

In diesem Zentrum wird eine Kombination aus Wellness, Fitness und Schönheitsbehandlungen angeboten. Auch in der Gestaltung werden die moderne Architektur mit der asiatischen Einfachheit kombiniert, um eine freundliche und entspannte Atmosphäre zu schaffen.

Ce centre offre un ensemble alliant wellness, fitness et soins de beauté. Son design mêle l'architecture moderne à la simplicité asiatique pour créer une atmosphère chaleureuse et relaxante.

Este centro ofrece una combinación de wellness, fitness y tratamientos de belleza. Su diseño mezcla la arquitectura moderna con la simplicidad asiática, y crea una atmósfera cálida y relajada.

Questo club offre contemporaneamente servizi wellness, fitness e trattamenti di bellezza. Il suo arredamento mescola l'architettura moderna con la semplicità asiatica al fine di creare un'atmosfera accogliente e rilassante.

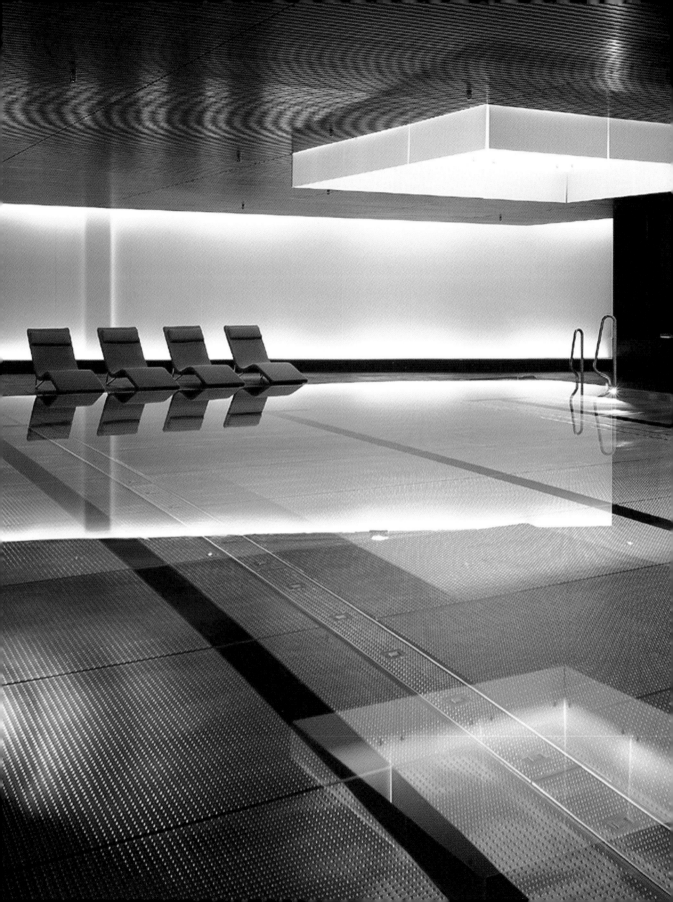

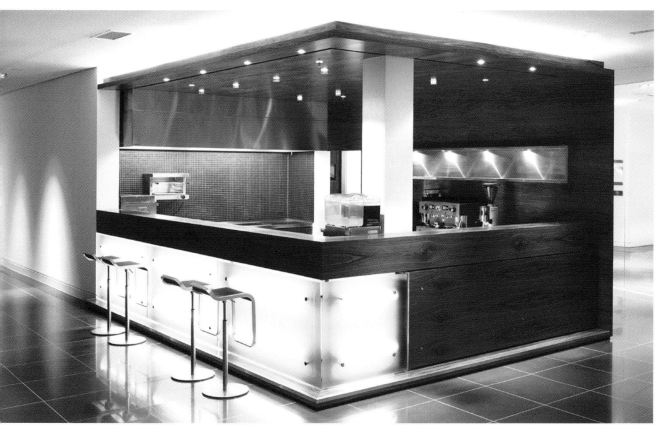

Soho House New York New York, USA

Architect: Jablin & Associates
Designer: Ilse Crawford & Nick Jones
Photography: Jenny Acheson
29–35 9th Avenue, New York, NY 10014
Phone: +1 212 627 9800
www.sohohouseny.com, reservations@sohohouseny.com
Services: Body care and beauty treatments, steam and scrumb rooms, cowshed spa, aromatherapy, hot stone massage, thai massage, yoga

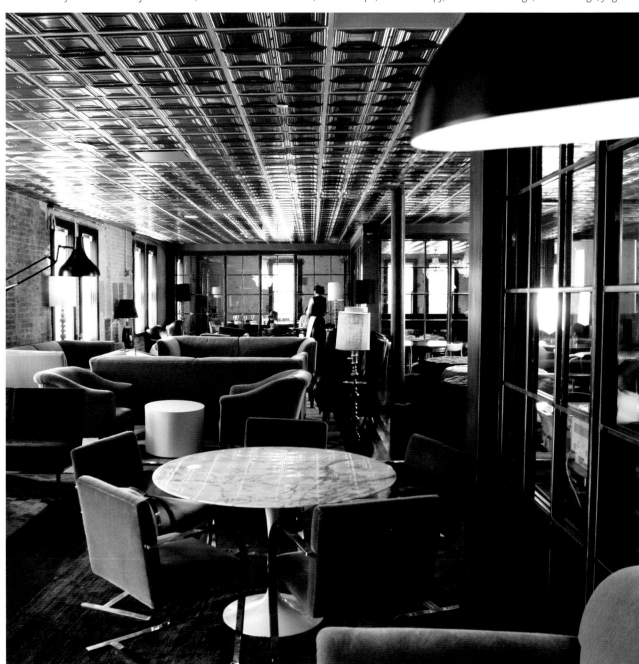

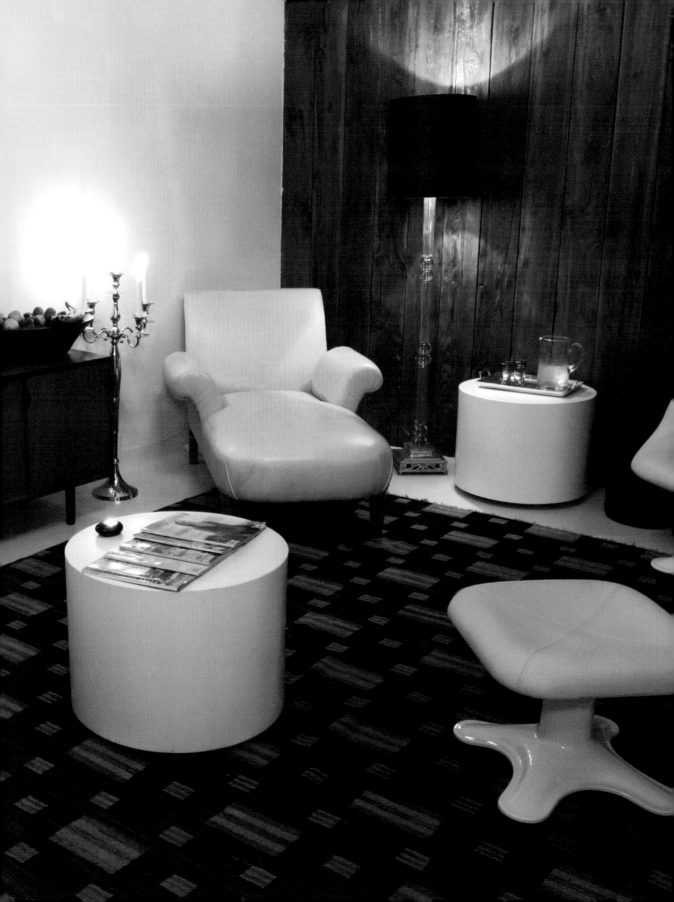

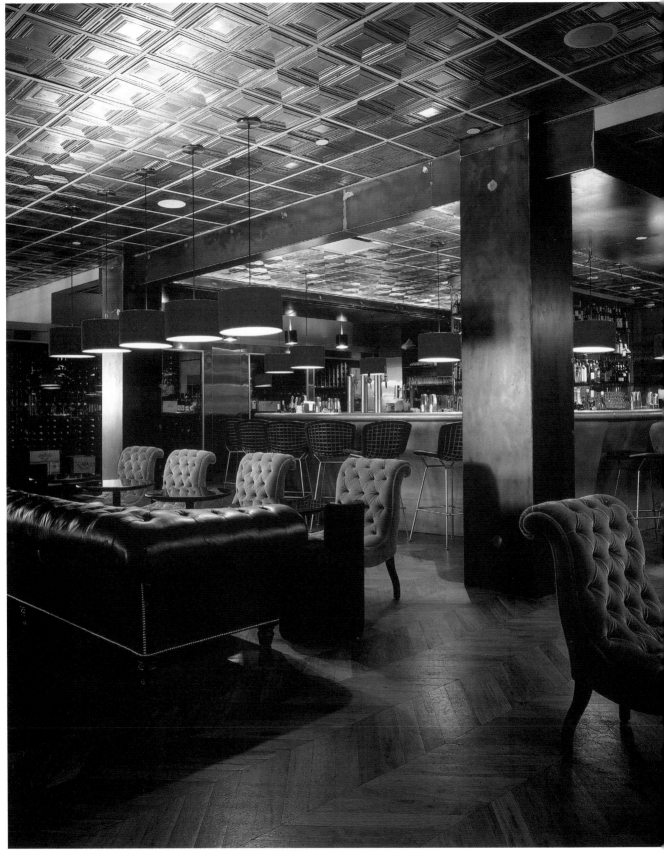

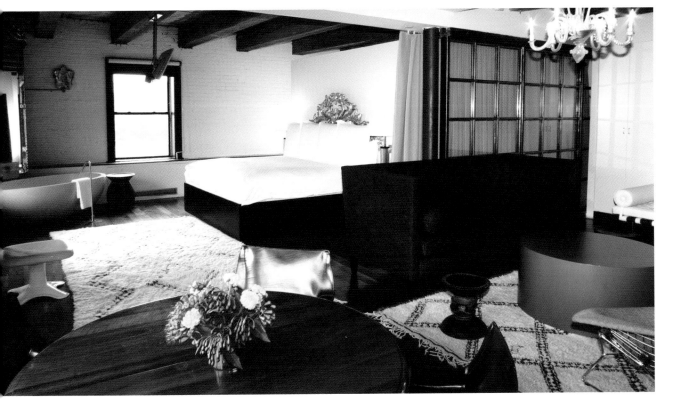

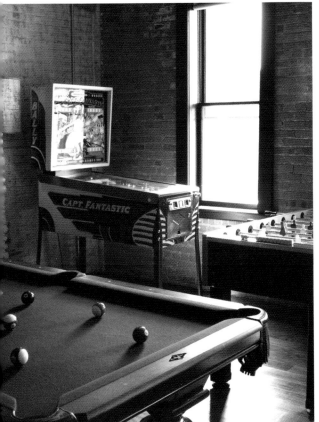

This four-story center was originally a warehouse. The modern, urbane design suits the tastes of a select clientele, which includes people from the film world and entrepreneurs.

Das vierstöckige Fitnesscenter war ursprünglich ein Lagerhaus. Das moderne und städtische Design ist auf eine Kundschaft zugeschnitten, zu der unter anderem Menschen aus der Welt des Films und Unternehmer gehören.

Autrefois un entrepôt, l'espace actuel comprend quatre étages. Le design moderne et urbain s'adresse à une clientèle sélecte, à savoir, entre autres, aux professionnels du monde du cinéma et aux chefs d'entreprise.

Este espacio actual de cuatro plantas era originariamente un almacén. El diseño moderno y urbano se ajusta a una selecta clientela que incluye, entre otros, profesionales del mundo del cine y empresarios.

L'attuale spazio di quattro piani occupa il posto di un vecchio magazzino. L'arredamento moderno si adatta a una clientela che include, tra l'altro, professionisti del mondo del cinema e businessmen.

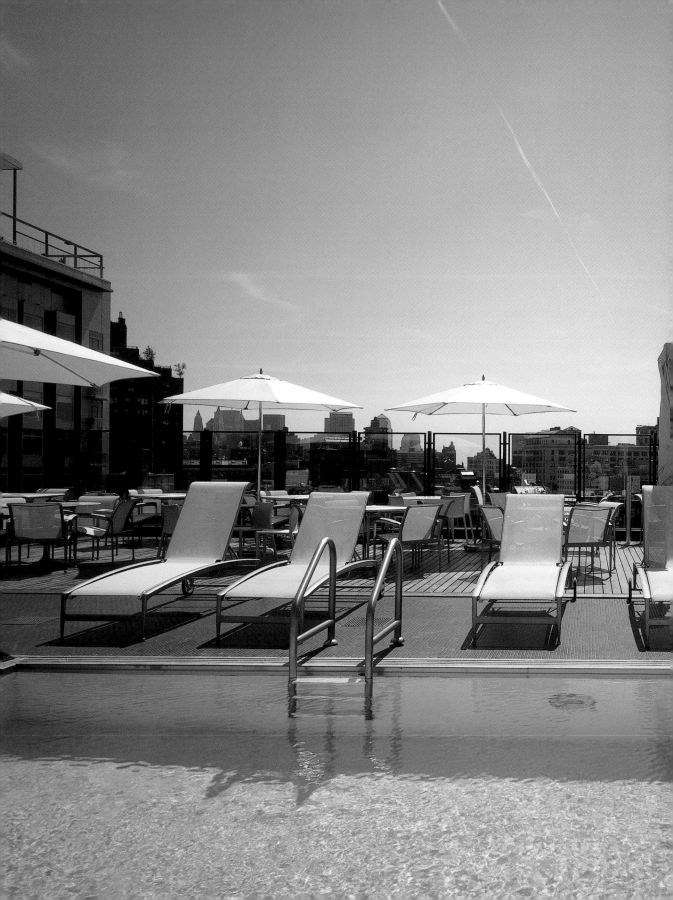

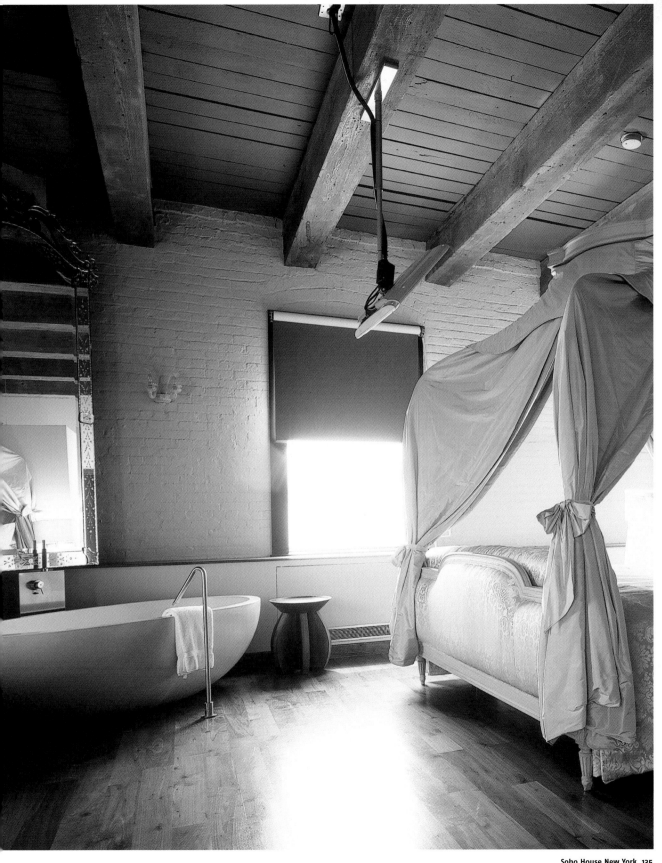